IMAGES
of America
CAMBRIA

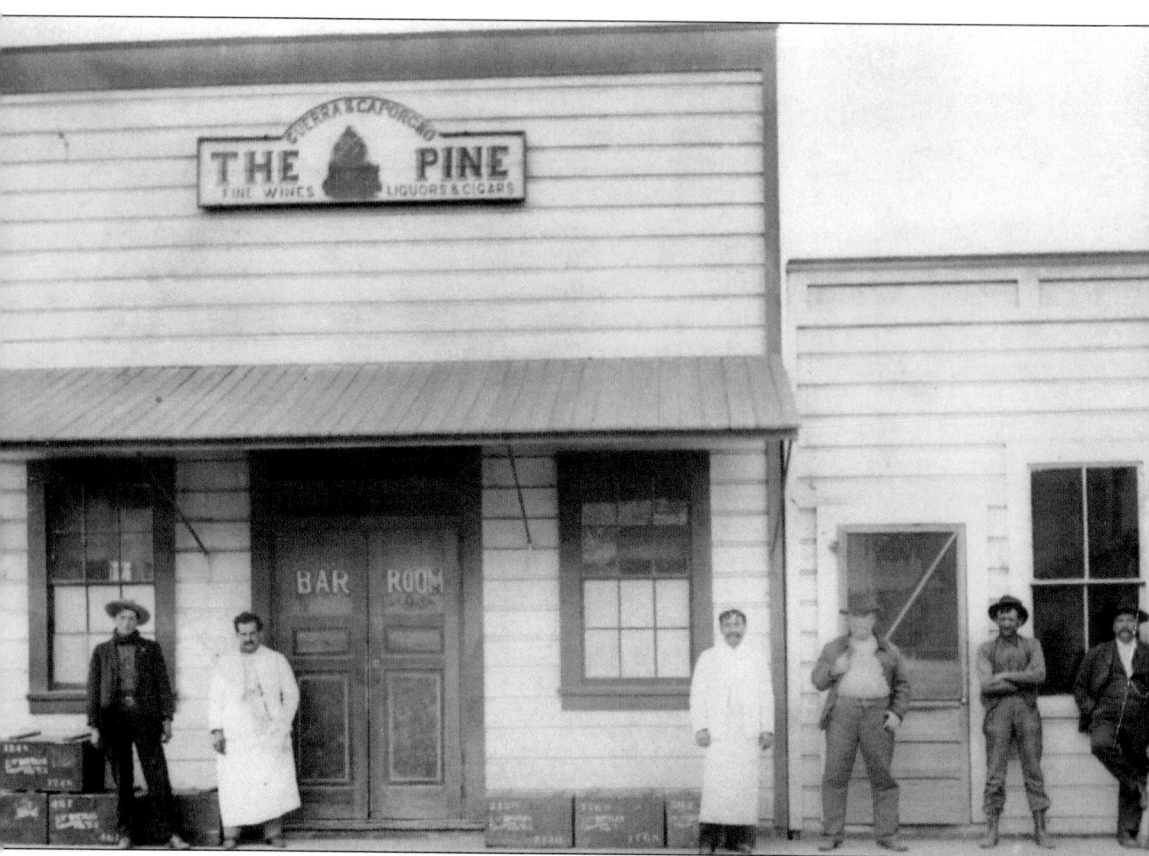

Attitudes toward Cambria's pine forest have changed over 200 years. During Cambria's early development, businesses often sported owners' names—Proctor, Lull, Ramage, Pollard—or generic names, like the Cosmopolitan Hotel. The Pine, located where Linn's Restaurant is now, was a rare early instance of a local business acknowledging the forest. Guerra & Caporgno were the proprietors who advertised "Fine Wines Liquors & Cigars." Note the barber pole next door. (Courtesy of the History Center of San Luis Obispo County.)

ON THE COVER: A lone car on the road is captured in the beauty of the Cambria pines. (Courtesy of the Cambria Historical Society.)

IMAGES of America
CAMBRIA

Wayne Attoe

Copyright © 2015 by Wayne Attoe
ISBN 978-1-4671-3310-4

Published by Arcadia Publishing
Charleston, South Carolina

Printed in the United States of America

Library of Congress Control Number: 2014957061

For all general information, please contact Arcadia Publishing:
Telephone 843-853-2070
Fax 843-853-0044
E-mail sales@arcadiapublishing.com
For customer service and orders:
Toll-Free 1-888-313-2665

Visit us on the Internet at www.arcadiapublishing.com

To the pines and people of Cambria

Contents

Acknowledgments 6

Introduction 7

1. The Forest Before 9
2. *San Benvenuto* to *Cambria* 21
3. Settling In 51
4. Celebrating the Town 77
5. Cambria Pines 91
6. Celebrating the Forest 109

Acknowledgments

Dawn Dunlap has helped me greatly with this project. She is a candid and discerning critic, a wealth of information, an accomplished editor, and a marvelous teller of tales. She connected me with sources of photographs and information that I otherwise would not have seen.

Several archives and collections have been of much value to me. The Cambria Historical Society (CHS) has a great and growing collection of images. Jack Breglio was enormously helpful in making them available. The History Center of San Luis Obispo County (HCSLOC) was equally valuable, and in particular, I thank curator Eva Ulz and Pam Helfert. Deann Underwood graciously allowed me to use images from her father's album, part of the Wilfred Lyons Collection (WLC). Through the courtesy of Richard Nock and Patricia Nock Marlo (RN and PNM), I had access to exceptional photographs by Alice Phelan Nock. Many of the nature images here are by Brad Seek (BS), who also made suggestions about the text. Photographs of Camp Ocean Pines (COP) are courtesy of Chris Cameron.

Institutional sources were the United States Department of Agriculture (USDA); Bancroft Library, University of California, Berkeley (Bancroft); California Historical Society Collection, University of Southern California Library (USCL); Black Gold Cooperative Library System (BGCLS); Land Conservancy of San Luis Obispo County (LCSLOC); National Library of New Zealand (NLNZ), California Department of Fish and Wildlife (CDFW); and California State Mining Bureau (CSMB). A few photographs are my own (WA). Other illustrations are credited in the text.

I thank Bev and Jerry Praver for their informative website cambriahistory.org (CHX) and responding to my questions. John Ehlers, president of the Cambria Historical Society, made a special effort to help me find photographs. Bert Etling, then-editor of the *Cambrian*, allowed me access to its morgue, which proved to be enormously useful. David Middlecamp helped secure photographs from the *Tribune* in San Luis Obispo. The photograph on page 120 is © 2002–2014 by Kenneth and Gabrielle Adelman of the California Coastal Records Project, which can be found online at californiacoastline.com. The drawing on page 37 is from Myron Angel, taken from *Thompson & West's History of San Luis Obispo County, California* (originally printed in 1883, and reprinted in 1966).

In addition to individuals credited in the text, I thank Jesse Arnold, Allan Ochs, David Houtz, Dave Bidwell, Dave Evans, Kevin Cooper, Jim Ellman, Merle Bassett, Milene Radford, Steve Brody, Debbie and Robert Soto, Joen Kommer, Mary Ann Carlson, Destiny Carter, Linda Haskins, Rev. Mark Stetz, Alexandra Bevk, Patti Duty, and Chris Mancini. Special thanks to Donald Archer and Richard Hawley for starting me down this path.

Introduction

Thousands of years ago, the Cambria forest was part of a much larger pine-oak forest that stretched from north of San Francisco to San Diego. Its characteristic tree is the Monterey pine (*Pinus radiata*). The forest, mountains, and ocean were home to Native Americans beginning about 10,000 years ago. Chumash and Plano Salinans were the people making their home in this landscape when Europeans first sighted it. They remarked on the trees and how they might be useful for ships' masts. The journal of Don Gaspar de Portola's expedition along the California coast in 1769–1770 described a particular site near the future Cambria that would be suitable for a mission.

When mission lands were laid out, the Cambria area was made part of Mission San Miguel Archangel, which is 35 miles inland from the coast. It was only after missions began to be secularized in 1836 and land grants were distributed that land could actually be subdivided and sold. Rancho Santa Rosa had been granted to Don Juliano Estrada in 1841. In 1864, through foreclosure and sale, 12,000 acres of it were transferred to Don Domingo Pujol of San Luis Obispo. The remainder of the original rancho was purchased by Sen. George Hearst in 1865 and 1890. In 1866, Don Pujol subdivided his holdings and sold them to settlers. By some, this is taken as the date of Cambria's founding. It took four more years and some confusion over names before a post office was designated Cambria in 1870.

But fortune-seekers and entrepreneurs had not waited for a town to be named. Cinnabar was discovered in the mountains in 1862, and mining flourished. Whaling was underway at the bay named San Simeon, and the forest was being logged. There was a drought that killed most of the Spanish cattle brought during the mission era. They were replaced with dairy cattle, which made the production of butter and cheese possible. Cambria became the second-largest town in San Luis Obispo County and a popular destination for festivities like Swiss Independence Day, the Fourth of July, and rodeos. The area had been populated by an array of nationalities. Portuguese Azoreans were prominent in whaling and Swiss Italians in dairying. Americans and other Europeans were among entrepreneurs setting up businesses. The Chinese found a niche market in drying sea lettuce and abalone for export to China. For these activities, the Cambria forest provided timber and firewood and then became a backdrop.

The Great Fire of 1889 devastated Cambria's business district. The railroad coming north passed the town. The market for mercury was volatile; mines closed, opened, and closed. With the decline of migrating whales, the whaling station at San Simeon closed in 1894. The local pine forest had been quickly logged over, and as a building material, pine could not compete with more durable redwood, so sawmills quieted. In the 20th century, government regulation of dairies became more stringent. Beginning about 1925, dairy farms were consolidated and converted to beef cattle ranches.

During these decades, a regular source of jobs came from the Hearsts. George Hearst had gradually acquired an enormous ranch that needed ranch hands. His son, William Randolph

Hearst, began building La Cuesta Encantada in 1920, which similarly provided employment for local people.

Automobiles and improved roads signaled a new era. In the eyes of Los Angeles developer Harry E. Jones, the Cambria forest had a new use: second homes for southern California's growing urban populations. Jones and his brothers purchased forested land adjacent to Cambria, then subdivided and marketed it as Cambria Pines beginning in 1927. At one time, there were sales offices in Los Angeles, Fresno, Long Beach, and San Francisco, and a singing cowboy promoted Cambria Pines on Long Beach radio. In physical size, Cambria Pines was 20 or 30 times as large as Cambria. Lots in the pine forest came with a water supply, and there was a small, new, and separate business district. For decades, people carefully distinguished between the two communities. Cambria was a town with stores, saloons, a post office, a bank, and churches. Cambria Pines was a resort with businesses that catered to vacationers. Gradually, the distinction between the two entities has been lost, with the influx of retirees and urban escapees who did not experience the twinning of Cambria.

Cambria's attractiveness and accessibility increased with the completion of the coastal highway to the north in 1937. Though often closed by landslides, it nonetheless made Cambria part of a journey rather than the end of the road. The area grew, too, when it took on a wartime role with the military monitoring and defending the coast. The opening of Hearst Castle as a state park in 1958 swept the town into a new era of tourism. Improved highway access and people's desire to escape urban centers led to growth and development. This was accompanied in the 1970s by a growing awareness in America of the environment, its importance, and its fragility. Locally, people became concerned about the impact of development on the forest, which by that time had become just a remnant of the prehistoric woodland. It became evident that living in the forest meant removing its trees. A new attitude toward Cambria's forest, watersheds, ranchland, and the rural landscape emerged in the last 20 years. Consequently, there have been numerous successful efforts to conserve natural resources and wildlife habitat. About 68 percent of the Cambria pine-oak forest is protected, and the community of 6,000 remains unincorporated.

One

The Forest Before

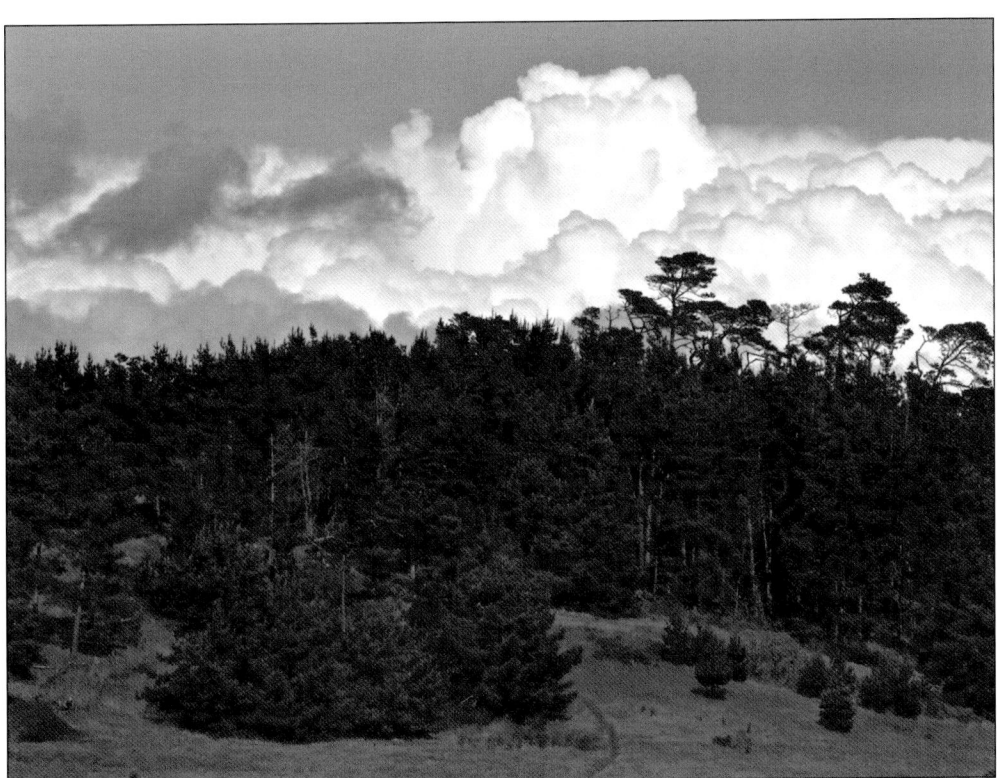

For many people, Cambria means pines. License plate holders proclaim, "Cambria Pines by the Sea." More specifically, Cambria's trees are Monterey pines. Elsewhere in the world, they are known as *Pinus radiata*, the scientific name. Thousands of years ago, these trees could be found along the California coast all the way from San Diego to well north of San Francisco. (Courtesy of BS.)

To understand what those long-ago pine forests might have looked like, one needs to travel to the Southern Hemisphere, where a remarkable 10 million acres are under cultivation in New Zealand, Australia, Argentina, Chile, and South Africa. That is the distinction: on the coast of what is now California, Monterey pines are native, have been around for millennia, and grow intermixed with other species, like coastal live oak (above). In contrast, the pines have been in these other countries less than 200 years. Grown on plantations, they are the product of cloning and other interventions to produce consistent, easily harvestable crops for lumber and paper pulp. (Above, courtesy of WA; below, courtesy of NLNZ.)

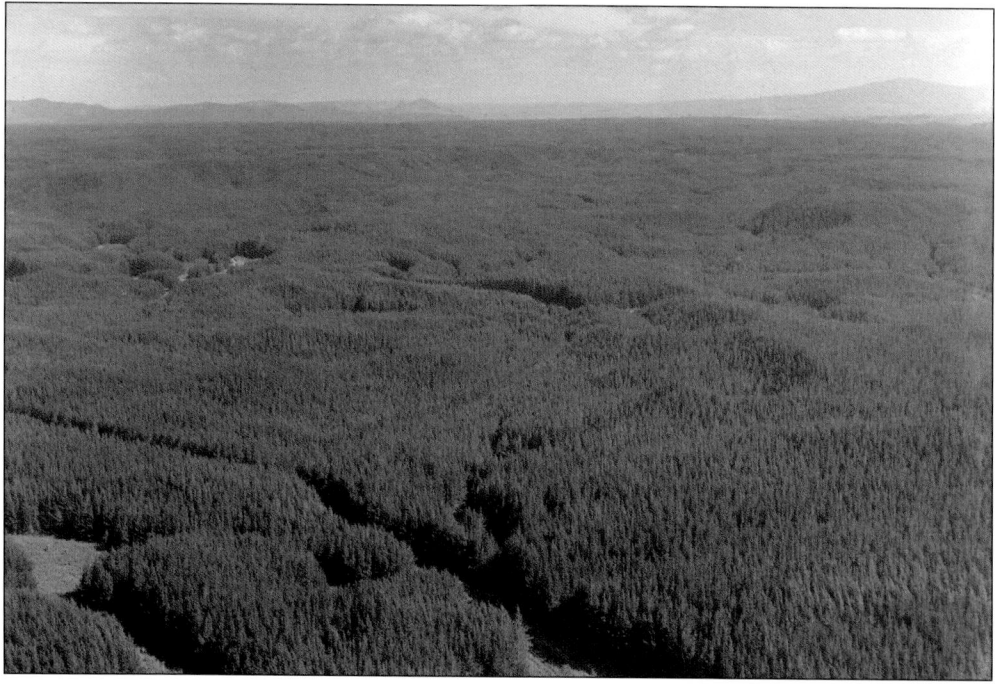

Over millennia, the North American forest's size varied with changing climate. Details about the scope, size, and character of that forest continue to emerge from ongoing research. What is clear, however, is that instead of countless acres of Monterey pine forest in the past, there are now only 15,000 acres left, with just 2,500 acres remaining in Cambria. Though it is in retreat and possibly facing extinction, the Cambria forest provides habitat for countless species, including California gray squirrels, which eat Monterey pine seeds and acorns as well as berries, fungi, and insects. Their fur is gray with a white underside, and they build nests in the treetops. (Right, courtesy of USDA; below, courtesy of BS.)

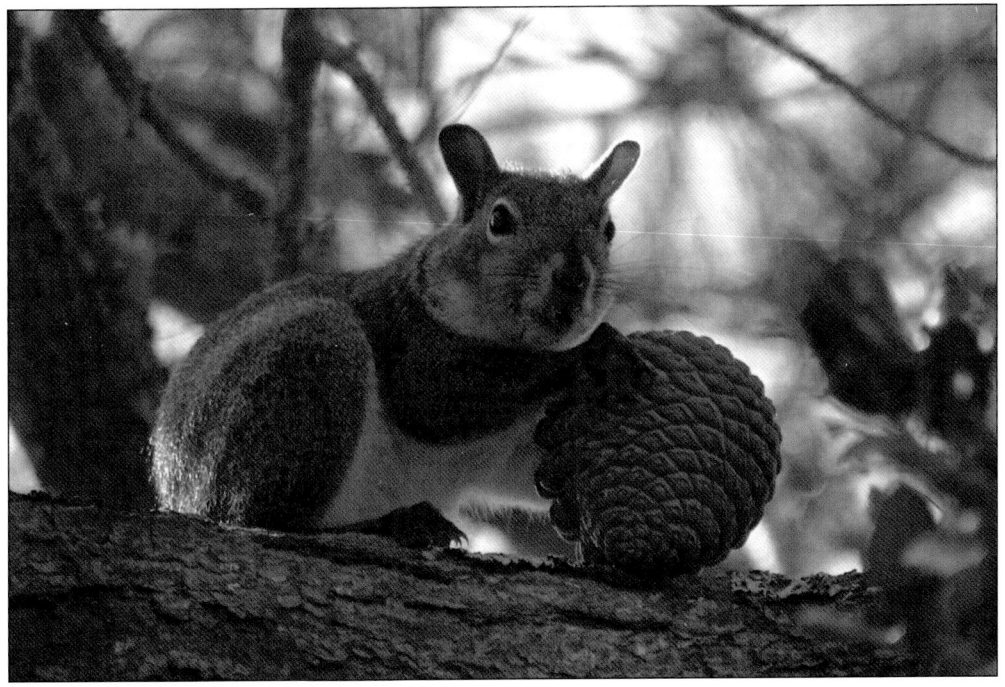

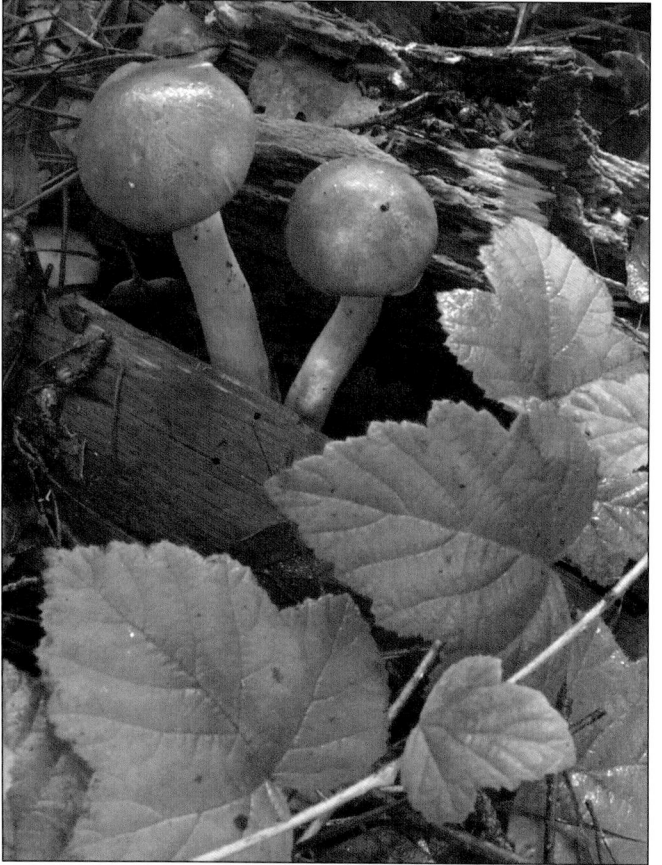

The pines people associate with Cambria were first noted by Europeans near Monterey Bay, which is how they came by the name. They are fast-growing, shallow-rooted trees that have adapted to the coastal climate. Rain in the coastal area comes largely in winter months, so summertime fog is needed to keep the pines alive during the dry season. Fog condenses on the pine needles and drips to the organic litter on the forest floor, moistening the shallow roots. In the forest context, roots intertwine, which helps stabilize the trees. Pictured below are mushrooms growing from a decaying pine log with a wild blackberry vine. (Both, courtesy of BS.)

A mature Monterey pine can reach 100 feet in height and has bark that is deeply fissured (right). In native stands such as Cambria's, trees live up to 100 years. Unfortunately, the shallow roots make them susceptible to toppling, so some do not reach that age. Monterey pines are closed-cone conifers, which means their cones are sealed with resin and open in response to heat. In past centuries, periodic wildfires accomplished this, but release can also be triggered by heat on warm days. Cones are asymmetrical and grow in radiating whorls around the tree branches. Scales on the cone also radiate, so the name *Pinus radiata* is appropriate. Needles are usually in groups of three. The pygmy nuthatch (below) is a tiny songbird often found in pine forests. (Right, courtesy of USDA; below, courtesy of BS.)

Although Monterey pines predominate in these forests, the woodlands are called pine-oak because they are intermixed with coastal live oaks. Oak trunks are often gnarled, and the leaves are stiff and leathery. The so-called moss that hangs from both pine and oak has several names, such as Spanish moss, but it is a lichen. Undergrowth in the pine-oak forest includes toyon, bracken, blackberry, poison oak, coast sagebrush, fuchsia-flowered gooseberry, osoberry, pink-flowering currant, and sticky monkey flower (below). The Monterey pine forest is a winter destination for monarch butterflies and birds such as the hermit thrush, Townsend's warbler, and red-breasted nuthatch. (Above, courtesy of BS; below, courtesy of USCL.)

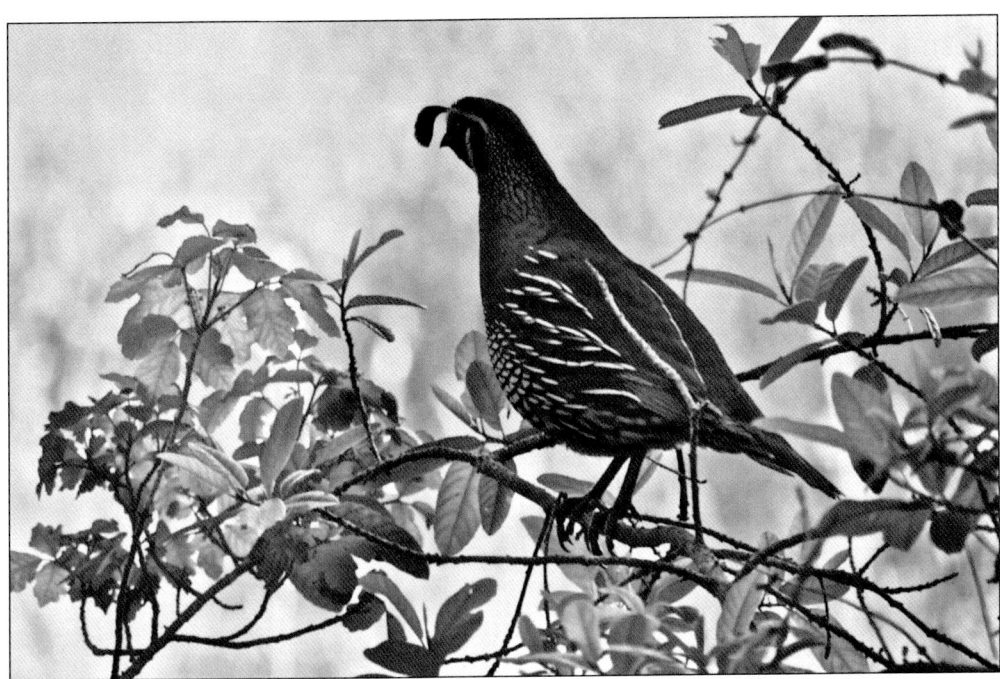

Humans arrived in the area about 10,000 years ago. Chumash and Plano Salinan peoples treated the forest as an ally. They tended the forest almost like a garden, producing food, medicine, and material for tools, shelter, and rituals. They pruned and planted. They dug edible roots known as Indian potatoes and replanted some for another season. They gathered seeds and nuts. Nearly every plant species had a use. For example, pine nuts were eaten raw, parched, or steamed and pounded into flour. Poison oak (above, left of the California quail) was a cure for warts and treating ringworm, and it was used as a dye in baskets. Coffeeberry (to the right of the quail) has berries that are sweet and edible. Grinding mortars (below) were used to process acorns into a mash, which was leached and cooked. (Above, courtesy of BS; below, courtesy of HCSLOC.)

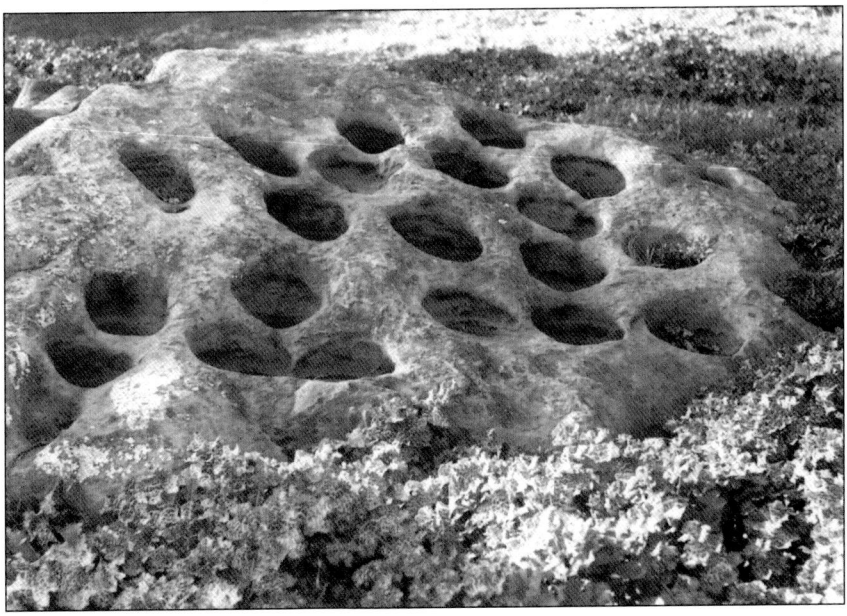

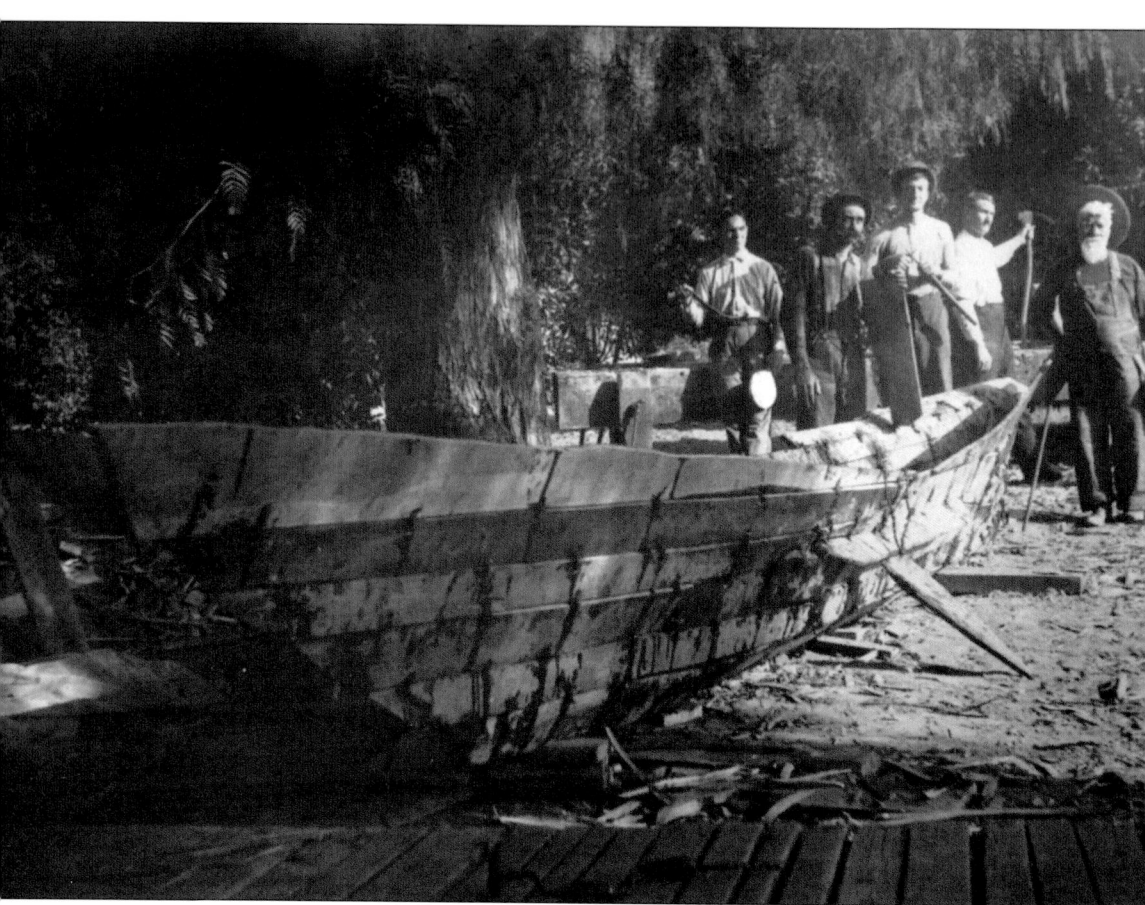

Tribes emerged, with the Chumash dominant on the central coast and Salinans overlapping in the northern area in the vicinity of Cambria. Chumash developed plank canoes made from pine or redwood that washed ashore. In the Chumash language, the word for canoe, tomol, also meant "pine." The wood was split and then shaped using with tools made from stone, antlers, or shells. Holes were drilled and planks tied together with fiber rope. Waterproofing was achieved with pine resin and tar that seeped from exposed rock. These canoes made it possible to fish in deep water and facilitated trade among villages. The tomol pictured here was built under the direction of Fernando Librado Kitsepawit for the anthropologist J.P. Harrington in 1912. Salinans, the smaller group, did not use tomols, but harvested abalone, clams, oysters, and mussels from along the ocean shore. The mountains and forest provided meat and hides, particularly deer, as well as bobcat, mountain lion, squirrel, coyote, and fox. (Courtesy of Santa Barbara Museum of Natural History.)

Native Americans on the central coast lived lightly on the land, so there is little lasting evidence of their presence. Chumash dwellings were built with circular willow frames thatched with tule, a grass found in wetlands. Salinan houses may have been square and supported by poles. Pictured here is a reproduction of a Chumash house under construction in 1923 in Ventura County. (Courtesy of BGCLS.)

Middens are accumulations of waste from daily life and among the few reminders of that earlier presence. These are identifiable because they do not support the growth of shrubs and trees due to the concentration of fire ash. They have yielded shells, bone, and stone tools. The circular opening in the forest at the lower left of the photograph is one of several midden sites in Cambria. (Courtesy of CHS.)

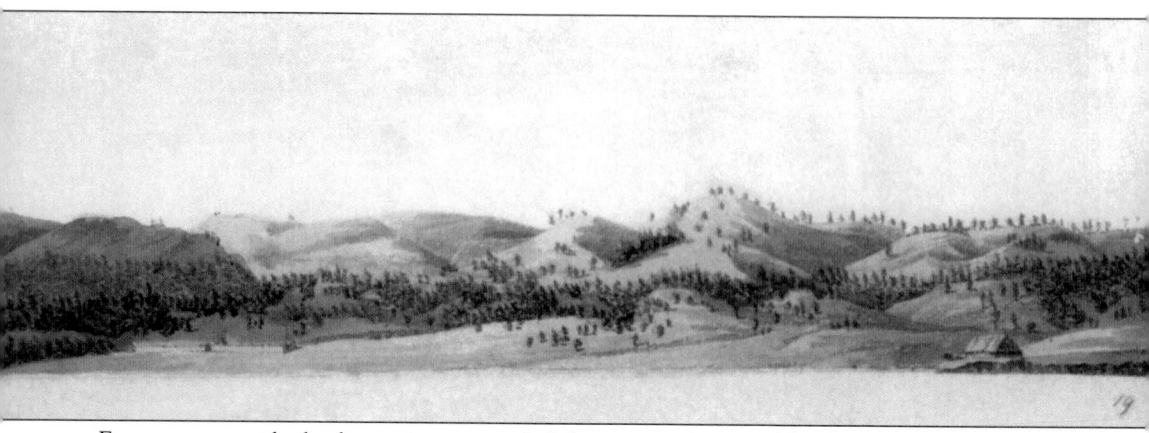

Europeans provide the first written record of this region. A journal by Friar Juan Crespi recounts the Don Gaspar de Portola 1769 exploration on behalf of the king of Spain. They headed north from San Diego to find Monterey Bay, which previously was sighted only from the sea. During their frequent encounters with native people during their trek, they were given baskets of *pinoles* (ground and toasted maize), seeds, *atole* made of acorns, fresh fish, and "very good tamales which seemed to be made of corn." When they camped near the current site of Cambria's Coast Union High School, Crespi remarked on the thick growth of willows, cottonwoods, pines, and other trees. He describes the local people as gentle and friendly, living both nomadically and in villages. In another encounter along this coast, the explorer George Vancouver pronounced the area to be "tolerably well wooded, even close down to the shore." A crew member, John Sykes, documented the pine-covered slopes at Monterey Bay. (Courtesy of Bancroft.)

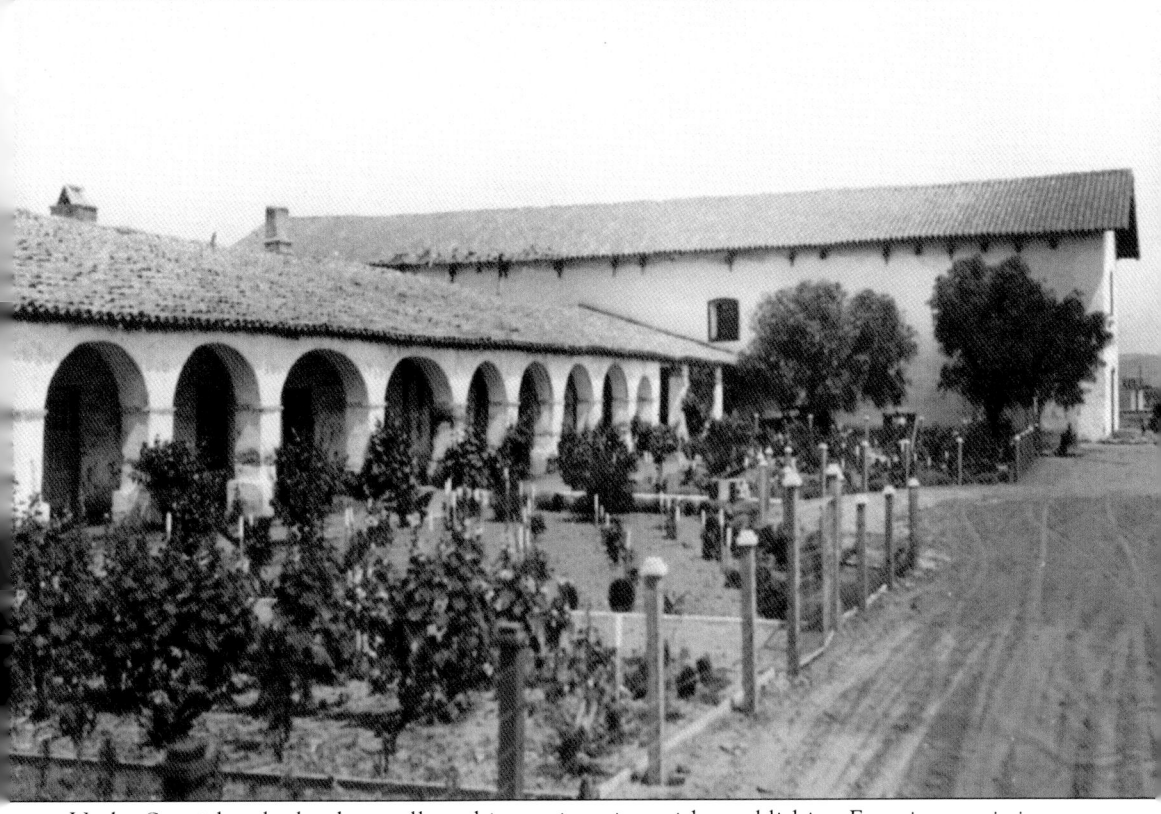

Under Spanish rule, land was allotted in conjunction with establishing Franciscan missions whose purpose was to evangelize to native peoples—principally Salinans—who lived in the area. Mission San Miguel Arcangel was founded in 1797 and located a day's journey from two other missions on the Camino Real. Its authority extended 35 miles to the coast, including the area that became Cambria. Cattle and horses raised on this expansive area contributed to the sustenance and economy of the mission. The existing church was built between 1816 and 1818 with interior wall frescos painted by native Salinan artists directed by Estaban Munras. At one time, about 1,000 Salinans were associated with the mission, and nearly 3,000 are buried there. In the 1830s, Mexico secularized mission lands and distributed them as land grants to individuals with family or business connections to the colonial hierarchy. One step in securing a land grant was submission of a *diseño*, or visual depiction of the land, to the Mexican governor of Alta California. (Courtesy of HCSLOC.)

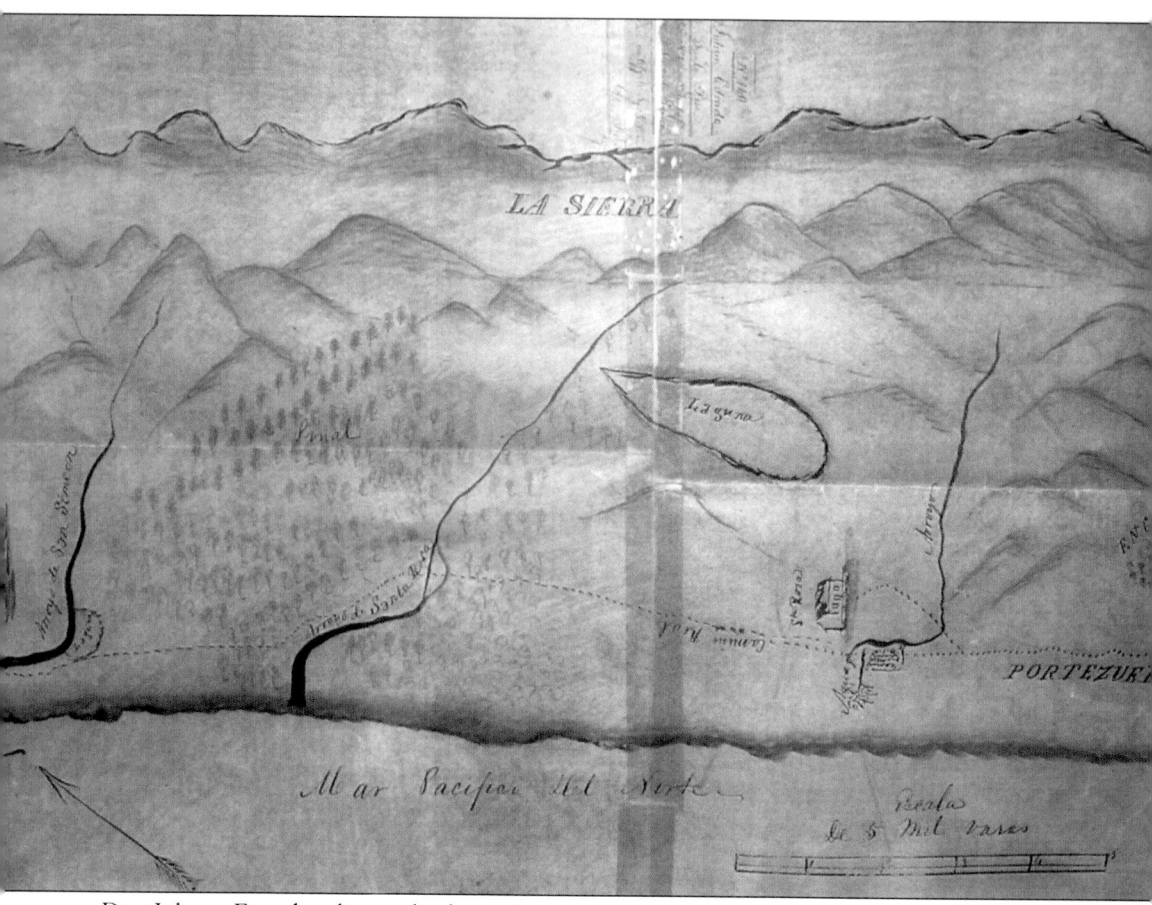

Don Juliano Estrada submitted a *diseño* for Rancho Santa Rosa. The landmarks are, from left to right, a building that was probably a slaughterhouse associated with Mission San Miguel, San Simeon Creek, pine forest (*pinal*), Santa Rosa Creek, Laguna (now a seasonal wetland), Estrada's adobe house, and an oak grove (*encinal*). The dotted line paralleling the coast is the trail, which had a toll for many years. The future site of Cambria is about where the trail crosses Arroyo de Santa Rosa. The 13,000-acre Rancho Santa Rosa was granted to Estrada in 1841. In 1864, Don Domingo Pujol acquired a large portion of Estrada's holdings through foreclosure and sale and then subdivided and sold parcels to settlers and speculators. Others trekked the area with a different purpose: identifying natural phenomena of the New World. For European naturalists, the coastal pine trees first identified at Monterey were noteworthy. An Irish physician named Thomas Coulter sent specimens to England in the early 1830s, and in 1836, a taxonomist named David Don named the species *Pinus radiata D. Don*. (Courtesy of CHX.)

Two
SAN BENVENUTO TO CAMBRIA

Settlement of the newly acquired land moved quickly. Settlers included businessmen who capitalized on the resources provided by the mountains, forest, coastal prairie, and ocean. Within a few years, industries that would be the foundation of Cambria's early economy were established: lumbering, mining, whaling, and dairying. The photograph of the Jeffrey Phelan ranch is one of many taken by Alice Phelan Nock around the turn of the 20th century. (Photograph by Alice Phelan Nock, courtesy of RN and PNM.)

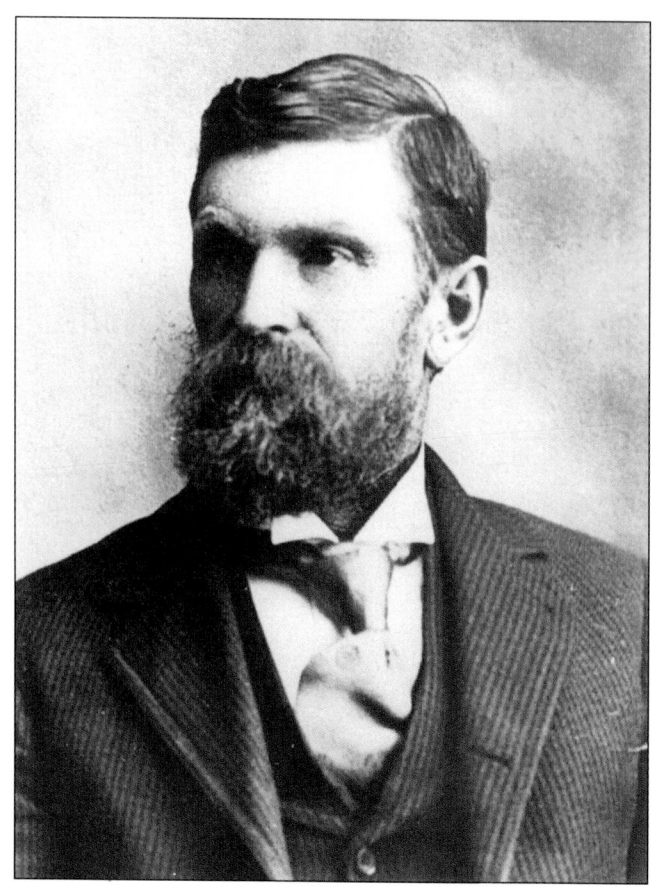

Development was aided by readily available pine timber. William Leffingwell Sr. (left) owned the first horse-powered sawmill, and a year later, he had a steam-powered mill. He also had the first grinding stone. A portable mill operated by others gave him competition. For a time, timber was transported for construction in Morro Bay and San Luis Obispo. An 1869 article applauded local lumbermen for doing "more for the advancement of this section of the country than any other material agency." A team of horses is shown below transporting logs with young pine trees in the background. (Left, courtesy of CHS; below, photograph by Alice Phelan Nock, courtesy of RN and PNM.)

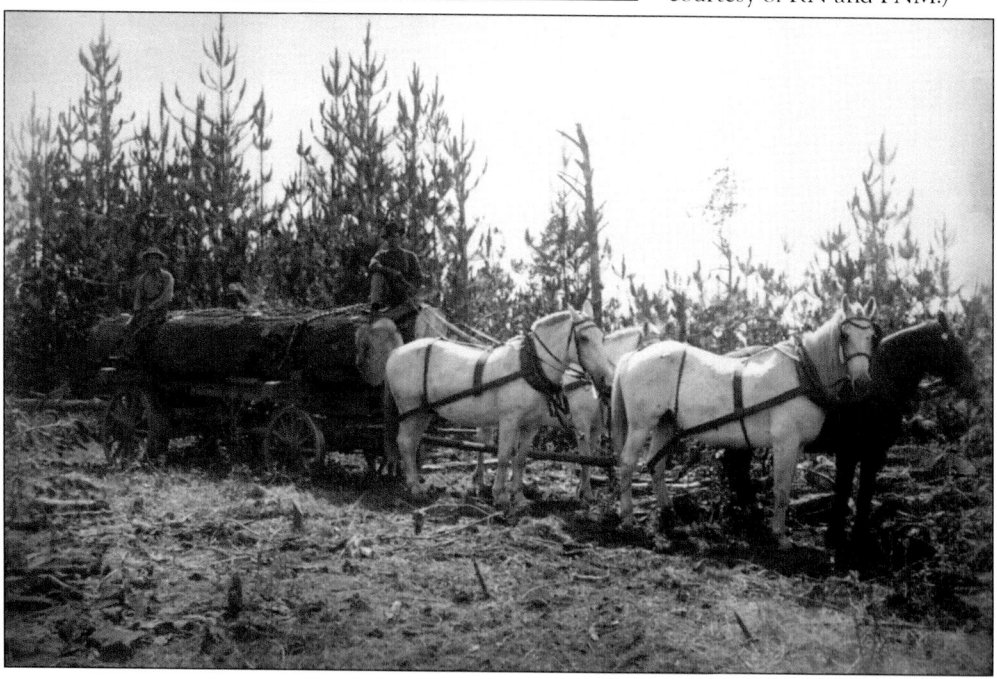

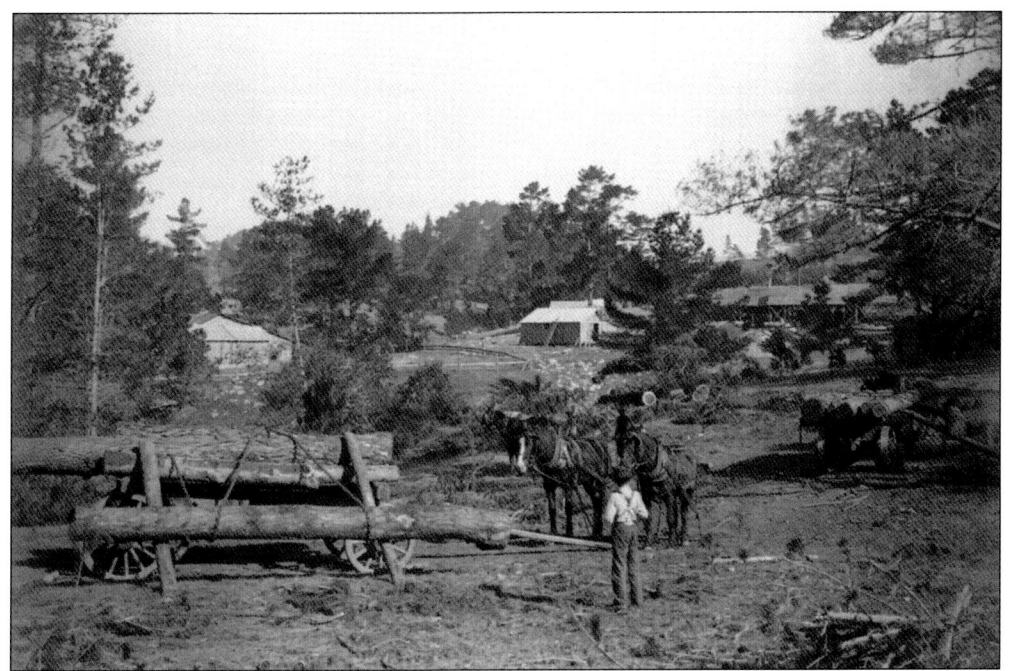

Timber for sawmills came from forestland acquired by mill owners and forested land that had been sold with the condition that it could be logged. Everyone who had lots along newly laid out streets needed lumber. This photograph shows a logging operation at the Phelan Ranch. Note that the heavy logs were loaded onto wagons using chains and skids. (Photograph by Alice Phelan Nock, courtesy of RN and PNM.)

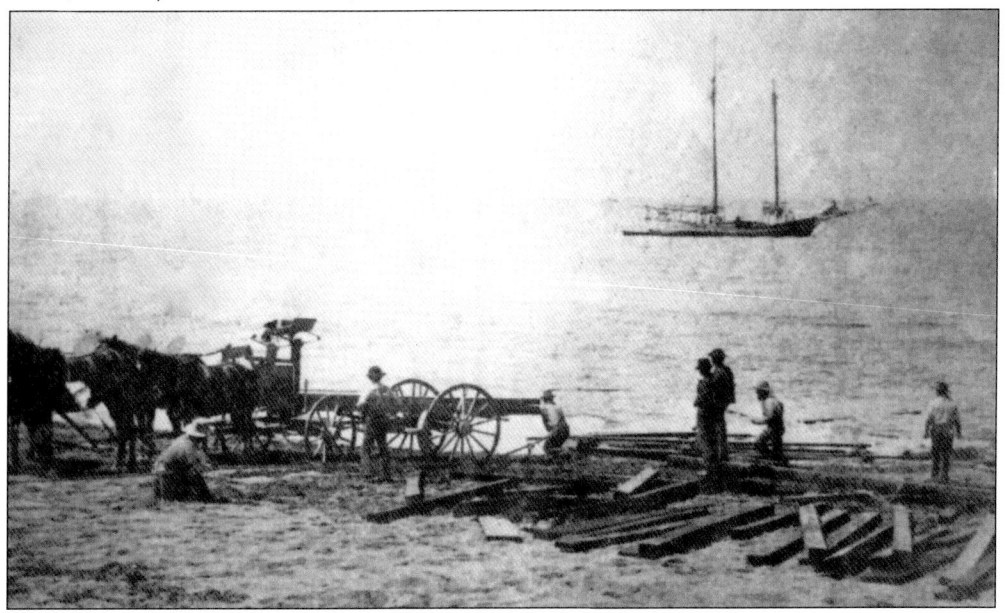

Timber from the local forest was soon augmented with imported material—particularly redwood—that was unloaded from ships and floated to shore at Leffingwell Landing. For those who could afford it, redwood was the more durable material. This photograph shows lumber being loaded onto a wagon on the beach. (Courtesy of HCSLOC.)

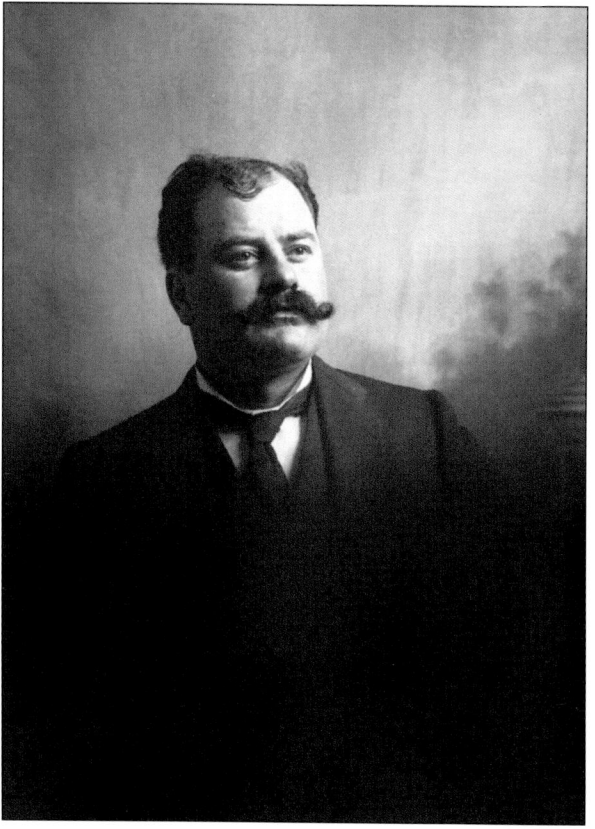

The worker's camp (above) was on Jeffrey Phelan's ranch. An Irish immigrant, he was among the earliest settlers. Previously, he had worked in the lead-mining industry in Illinois and gold mining in Amador County, California. He settled in San Luis Obispo County in 1858 and acquired land for stock raising and dairying. His wife, Alice Hearn, was also Irish, and they had six children, the eldest being the first European-American child born in the area. Phelan is credited as the builder of the area's first school, known as the Log School, near the mouth of San Simeon Creek. Federal government policy allocated an additional 320 acres to settlers who built a school. (Both photographs by Alice Phelan Nock, courtesy of RN and PNM.)

The first resident of Cambria was Jeremiah Johnson, who came west with his brother Jacob in the Gold Rush. They met James Monroe Buffum in the diggings, and the three traveled to San Jose and leased land to raise and sell horses. Encouraged by Judge Isaac Foster to buy land farther south, the three men moved their horses to the headwaters of Santa Rosa Creek in 1864. Then they sold the horses and split the money. Jeremiah built a small house and livery stable on upper Bridge Street. Technically, he was a squatter, for ownership of the land that became Cambria was not legally settled until 1866. The view is south down Bridge Street. Johnson's livery stable is the first long building in the lower right quadrant, just beyond the horses. His house is barely visible next door. The three-story building at the center of the photograph is the Proctor House hotel. Note that Bridge Street does not bridge the creek but fords it at the center of the image. The track beyond can be seen going up the bank. (Courtesy of Dawn Dunlap.)

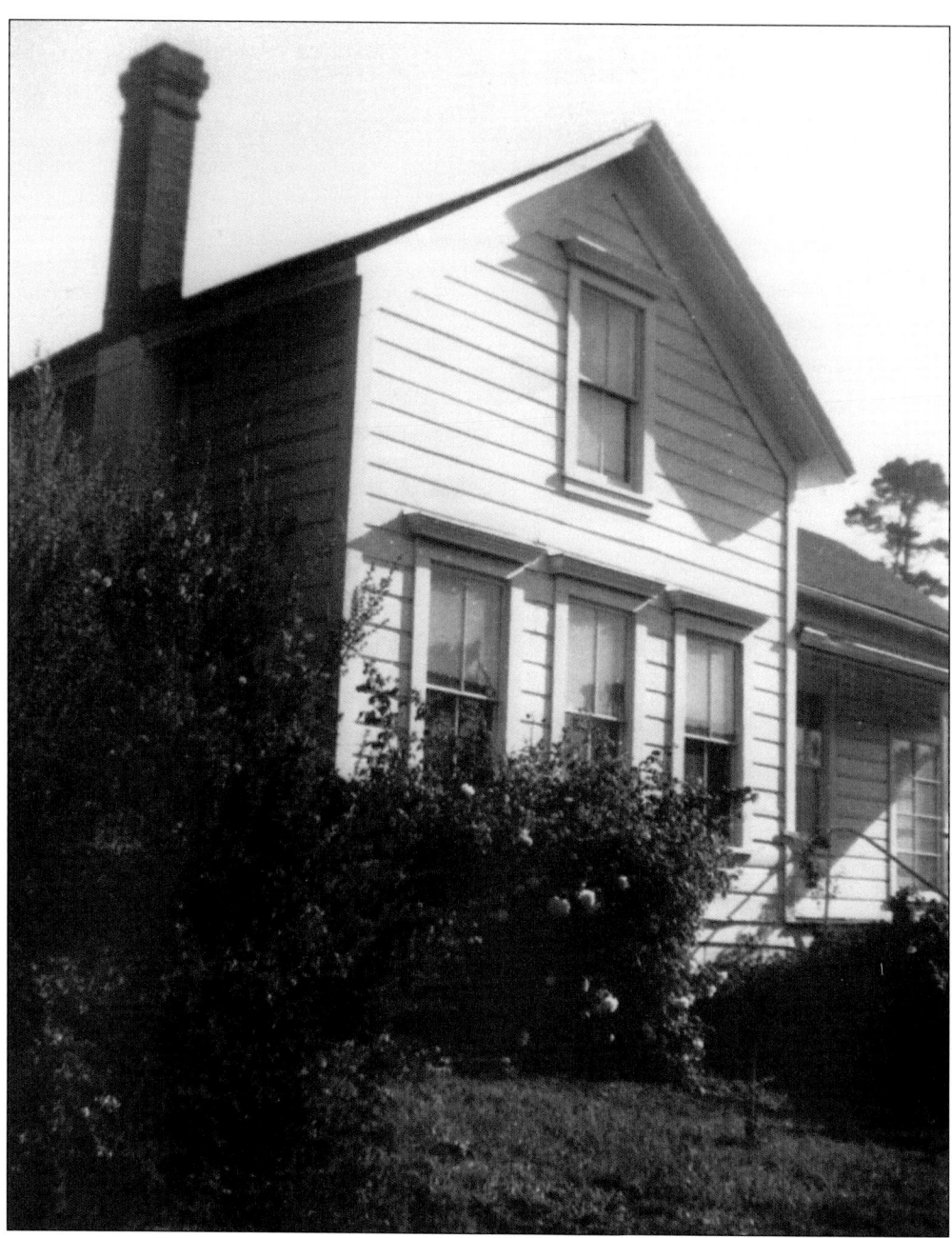

The building, which is likely one of the oldest remaining in town, was erected in 1865 as a general merchandise store with living space on the floor above. It was erected for George W. Lull and George Grant on the Santa Rosa Creek trail just east of the intersection of Main and Bridge Streets. (An earlier store had been on a bluff near the mouth of San Simeon Creek.) It was later remodeled and is now known as the Music House, for the family that later lived there. For a time, it was used as a lying in place for expectant mothers, useful especially for women residing on distant ranches who wanted to be closer to a physician. (For simplicity, the name *Main Street* is used here. In fact, that name was not officially adopted for the main east-west street until 1964.) (Photograph by Paul Squibb, courtesy of WLC.)

Built in 1870 of local pine, Cambria's first religious structure was a Catholic mission dedicated to St. Rose of Lima. Henry Williams, a Welsh immigrant, was the builder. The $100 for construction costs was raised at dinner dances in San Luis Obispo. The exterior pine siding appears to be narrow and lapped, but they are 2-by-10-inch boards routed to resemble lap siding. (Photograph by Sid Fridkin, courtesy of Dawn Dunlap.)

Visiting priests served mass. One of them is pictured here by the hammock where he undoubtedly slept. The building was used until 1963, and after that, it fell into disrepair. In 1978, a committee of native Cambrians undertook the challenge of restoring it. The original altar was discovered in the barn at the Phelan ranch. In 1982, Santa Rosa Chapel was listed in the National Register of Historic Places. (Photograph by Alice Phelan Nock, courtesy of RN and PNM.)

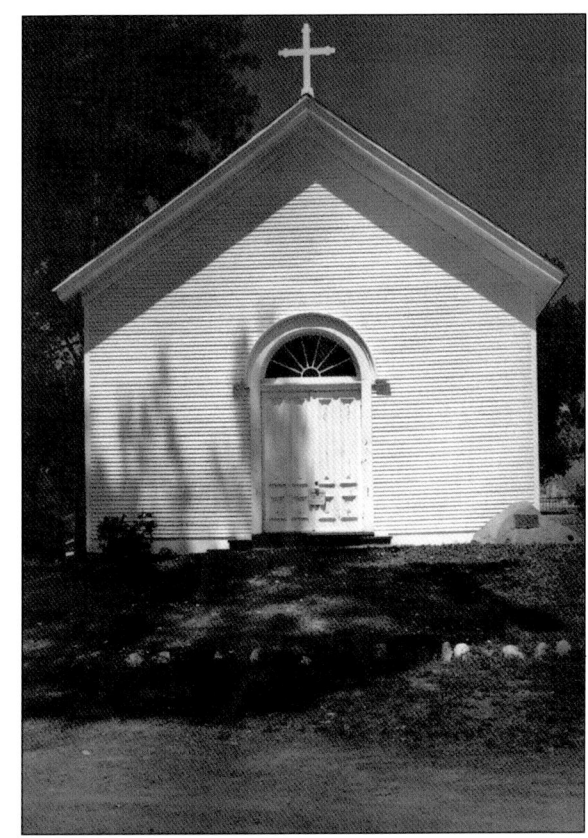

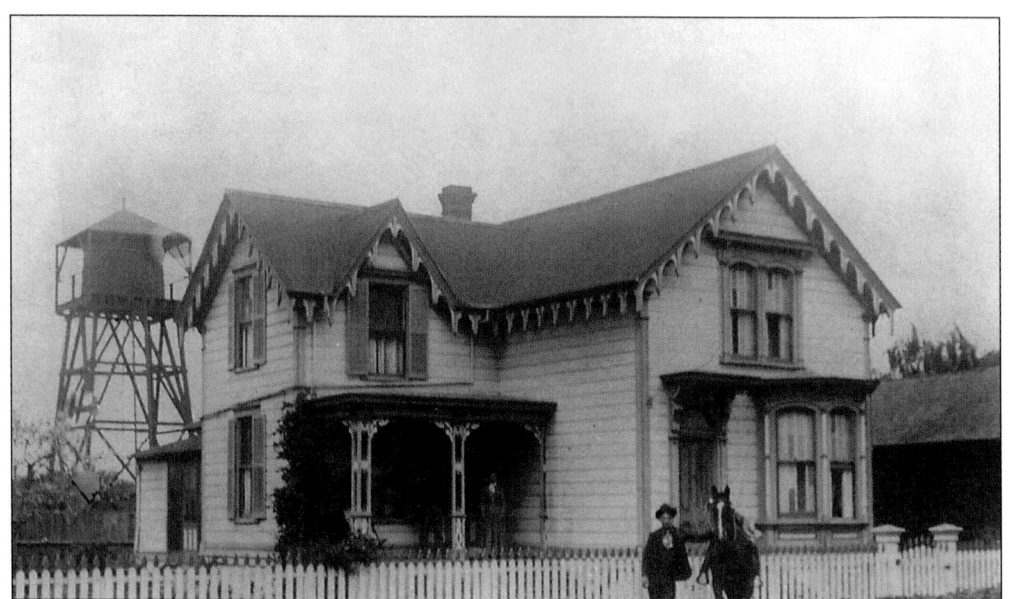

One of the town's most eye-catching houses (above) also used Monterey pine for studding, joists, and rafters. The exterior sheathing was redwood. It was built in 1877 for Frederick E. Darke. In 1953, the house was acquired by Paul and Louise Squibb, who restored parts that had deteriorated. A subsequent owner, Bruce Black, converted it into a bed and breakfast inn called the Squibb House. The elevated water tank behind the house was built by Alexander Paterson to provide water to the Lee and West Streets area. Many properties had their own wells. Cesspools returned wastewater to the ground. Planting nasturtiums around cesspools was a way to alert people to their location. In the lower photograph, the Squibb House is at the center, and the first Cambria school (left) and its larger replacement are on the hillside. (Both, courtesy of CHS.)

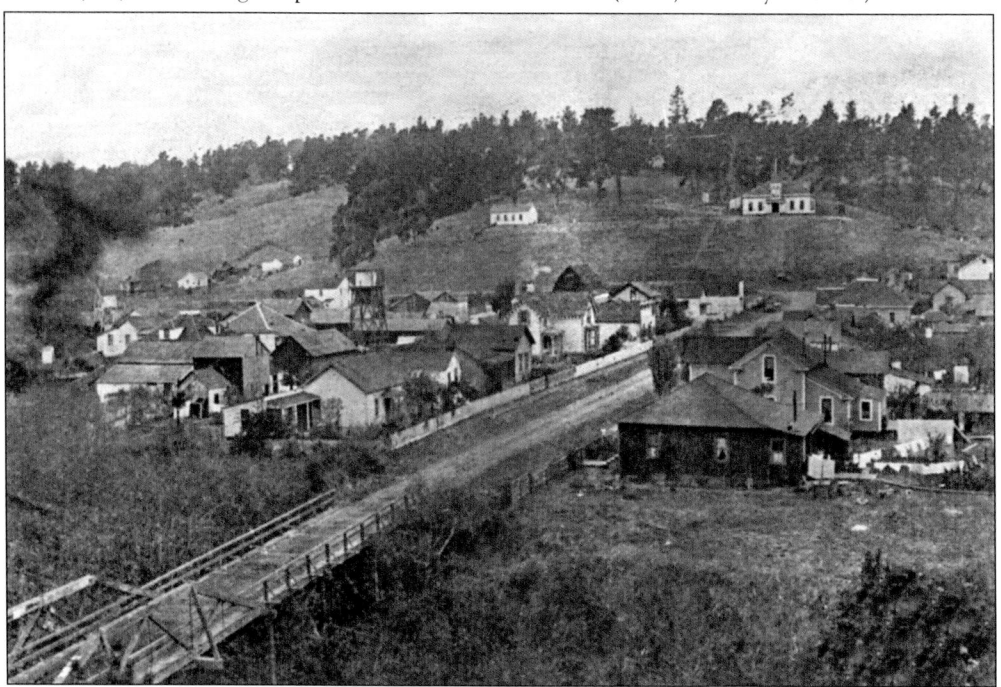

This house was also built out of local pine and imported redwood and transformed into a bed and breakfast establishment, the Olallieberry Inn. The house was built in 1875 for apothecaries and brothers Otto and Carl Manderscheid from Prussia. Later owners included Cambria businessman Benjamin H. and his wife, Blanche Music Franklin, and Amos and Ida Terrill Smithers. Amos Smithers was a dairyman and president of the Bank of Cambria. (Courtesy of CHS.)

Olallieberries, after which the inn is named, were hybridized from blackberry and raspberry stock about 1950 and have become associated with Cambria through the pies, jams, and sauces marketed widely by Linn's Fruit Bin. Pictured here in 1979 with the first pies are, from left to right, Carol Meunier, Mena Granatino, and Renee Linn. (Courtesy of Renee Linn.)

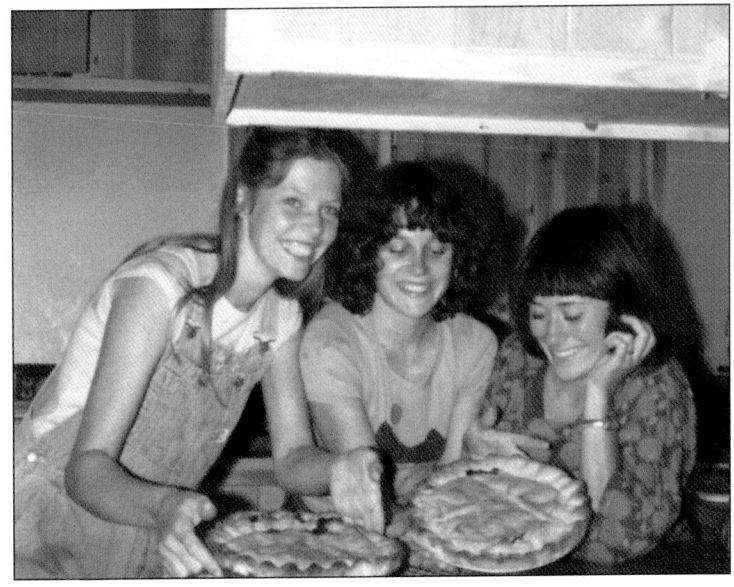

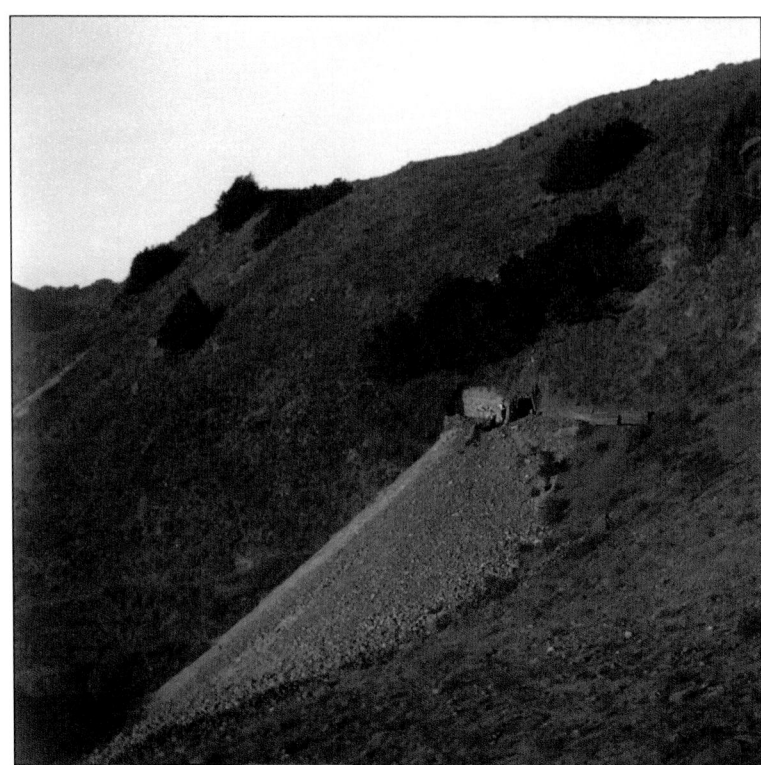

Pine was also used in local mines. Cinnabar had been discovered near Cambria in 1862, and there was a rush to stake claims and mine and process it for the quicksilver (mercury) it contained. Local timber was used for shoring mineshafts and fueling the fires whose heat released mercury from the ore. The exact location of this mine is unknown. (Photograph by Alice Phelan Nock, courtesy of RN and PNM.)

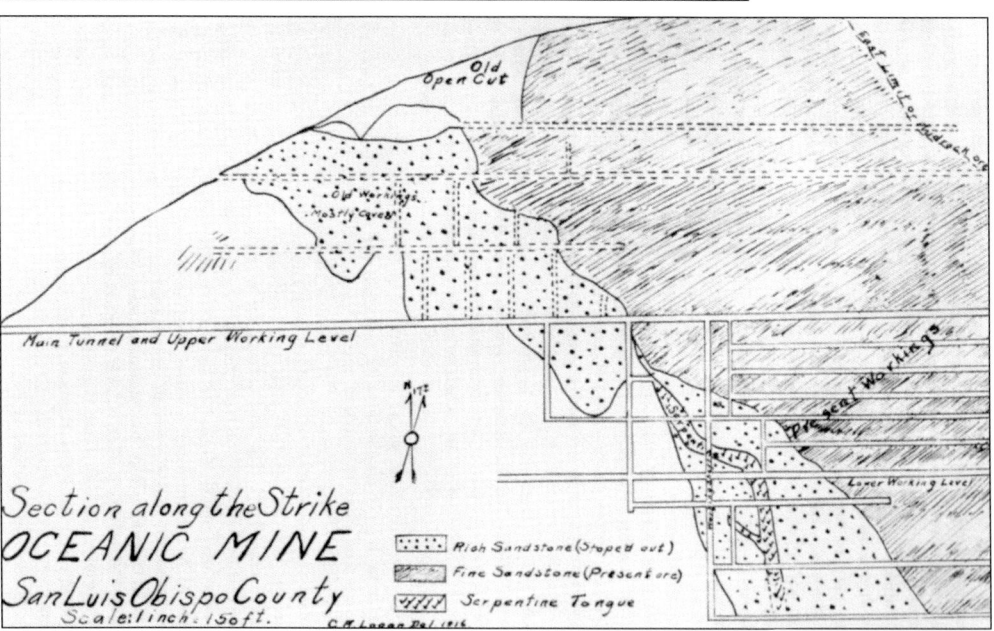

The Oceanic Mine was the largest in the area. At one time, it produced nearly as much mercury as all the other mines in the county and was the sixth-largest producer in the world. This drawing from 1916 shows old tunnels above and newer ones below, as well as the sandstone and serpentine formations miners faced. Candles were used for light, and shifts often worked around the clock. (Courtesy of CSMB.)

The mines provided work for local men and Chinese laborers who were out of work following completion of the railway to San Luis Obispo. Ah Louis (his given name was Wong On) had emigrated from China. He worked in several industries in San Luis Obispo, including organizing Chinese workers for construction of the Southern Pacific Railway Company. Similarly, he organized Chinese laborers to work in Cambria-area quicksilver mines. As many as 200 were employed as general laborers at the furnaces, cooks, and for a time, in the mineshafts. They made bricks, too, as Ah Louis established a brickyard near the Oceanic Mine. Bricks were needed to build the furnaces. It is reported that the first brick building in Cambria was made of bricks originating there. The location of brickyard shown below is not recorded. (Right, courtesy of HCSLOC; below, photograph by Alice Phelan Nock, courtesy of RN and PNM.)

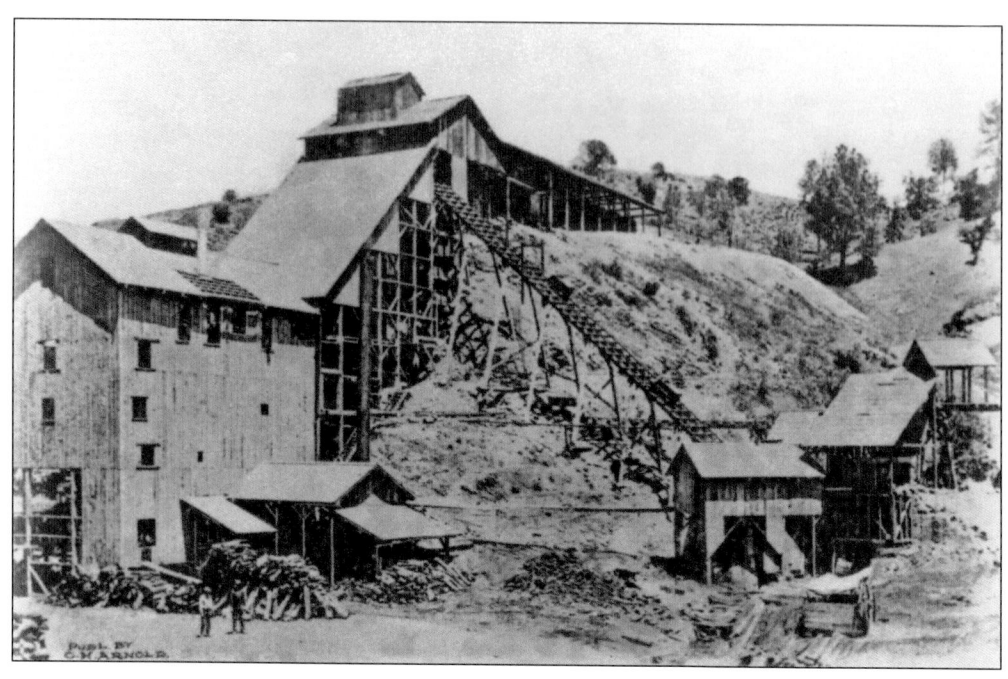

East of Cambria, at the Adelaida settlement, the Klau Mine (above) was developed. In the lower left of the photograph, stacks of logs are ready for the fire. The Cambria Mine (below), on a hillside above San Simeon Creek, was first developed in 1903 by Elmer S. Rigdon and had tunnels stretching 1,000 feet underground. The son of Rufus Rigdon, a notable Cambrian, Elmer Rigdon typified the entrepreneurial spirit of the time, owning buildings and ranchland, investing in mining, establishing a brickyard, and eventually being elected to the state assembly and then to the state senate. Mercury prices fluctuated dramatically over many decades, forcing mines to close and reopen in response to the market. The 1960s saw the last mercury production in the area. One of Cambria's nicknames was "City of Cinnabar and 1,000 Pines." (Above, courtesy of HCSLOC; below, courtesy of CSMB.)

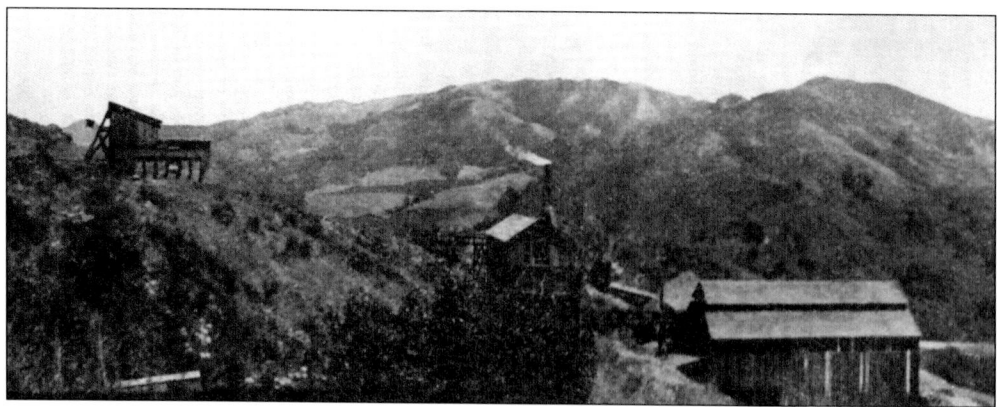

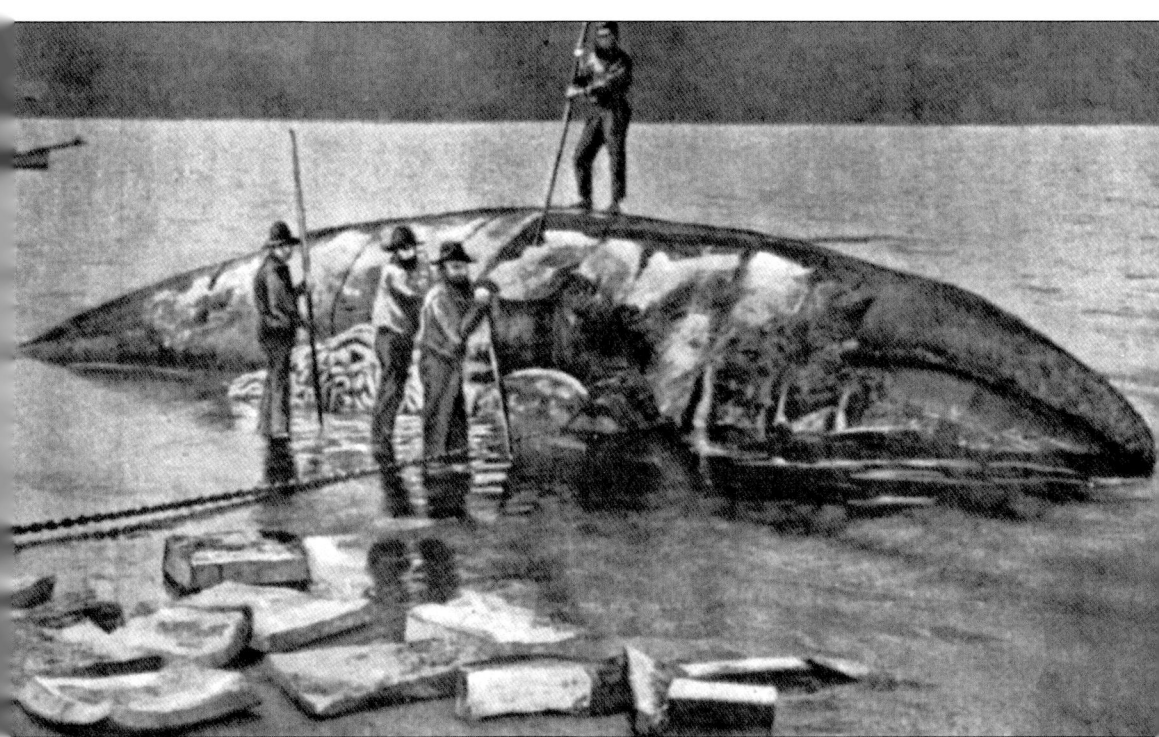

On the coast north of Cambria, a whaling industry developed where a curving peninsula creates a sheltered bay at San Simeon. Joseph Clark, a Portuguese Azorean, established a whaling station there in 1864. One account claimed whales were seen blowing almost every hour of the day. The station was near the tip of the point. For the most part, the catch was gray whales that were intercepted while migrating. When they were spotted, men in small boats put out from shore. Once they had harpooned the whale, they used an explosive device to kill it. If that did not work, boatmen held fast until it died. The whale was towed to the station where the blubber was flensed (cut in strips). The blubber was boiled in large cast-iron pots to release its valuable oil, which was then shipped in barrels to San Francisco. The residual flesh provided fuel for the fire. The largest catch in a season (November until April) was 33; the smallest catch was 3. Workers at the station were largely Azoreans. (Courtesy of CDFW.)

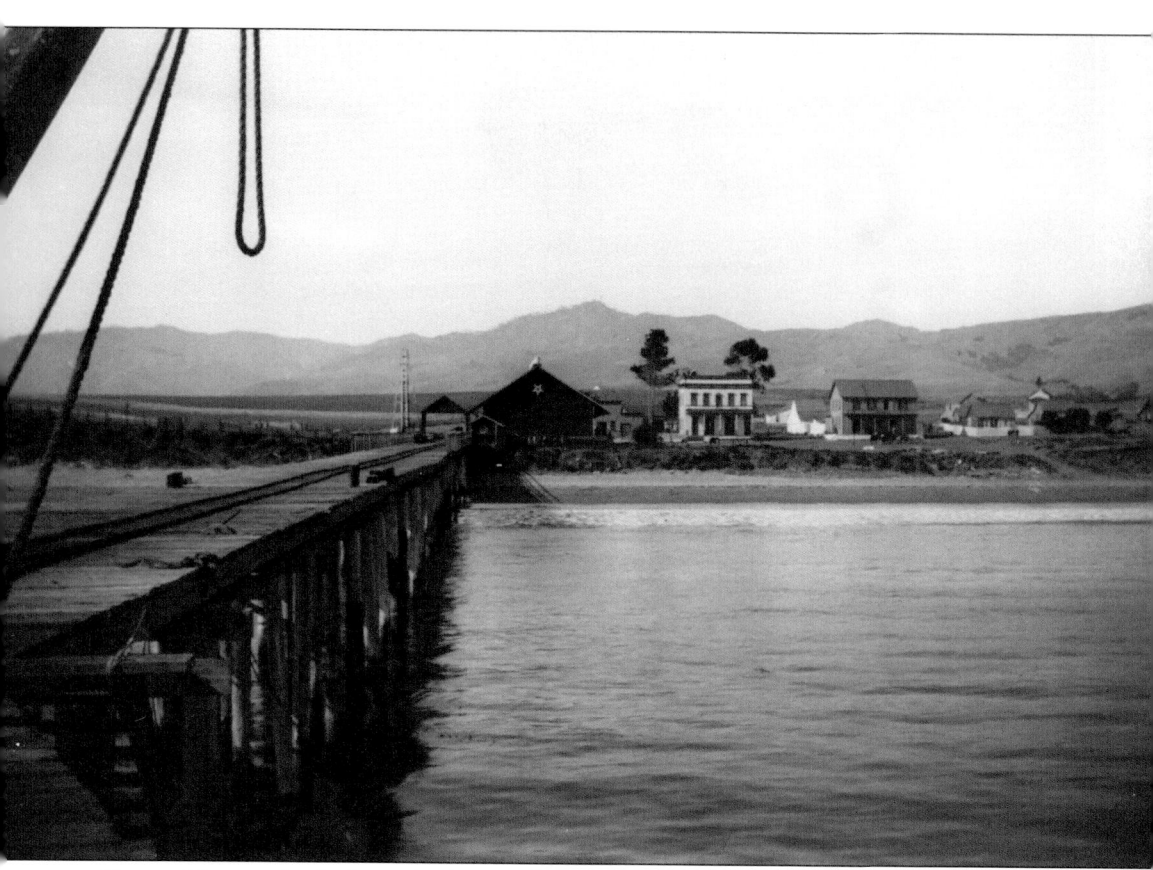

George Hearst, who had struck silver in the Comstock Lode, began a long process of acquiring thousands of acres of land near San Simeon. Hearst and Clark would eventually collaborate to build a pier from which products from the region could be shipped and cargo received. Lull and Grant, the merchandisers in Cambria, built a store and warehouse at San Simeon. With increased activity as a port, the settlement at San Simeon grew in the 1870s, eventually boasting homes, hotels, and warehouses, as well as a butcher shop, blacksmith shop, livery stable, and school. Pictured here from left to right are a large warehouse, then behind it is Sebastian's Store, followed by the white Thorndyke Hotel, the Bay View Hotel, and the Pacific School with a belfry. (Photograph by Alice Phelan Nock, courtesy of WLC.)

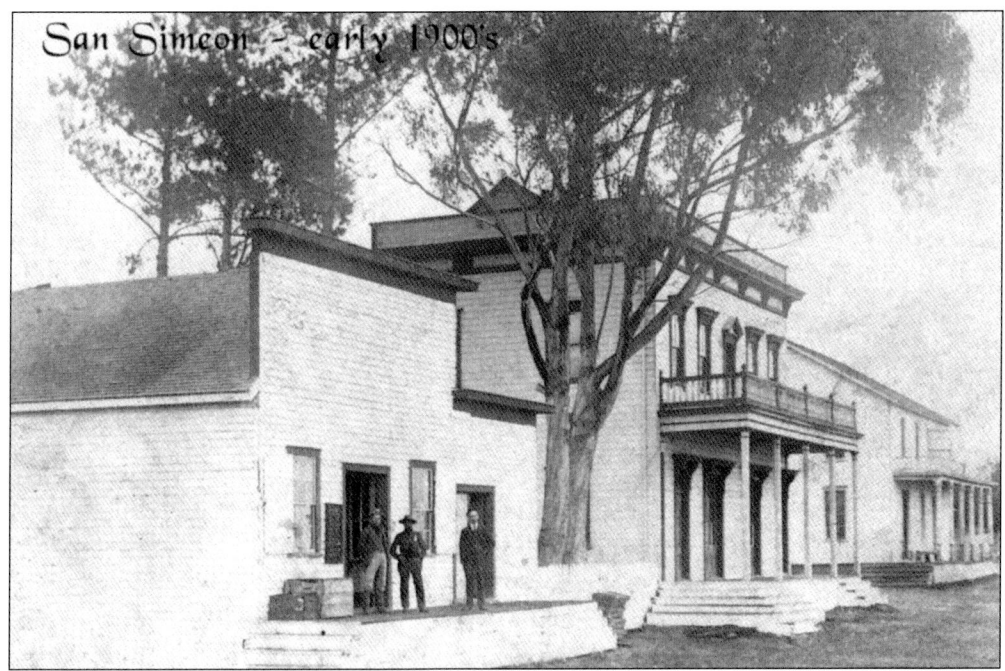

Construction of a pier allowed San Simeon to receive ships that plied the coast between San Francisco, Monterey, Los Angeles, and San Diego. It shipped farm products, butter, and cinnabar and received manufactured goods needed in the growing region. The building on the left (above) was constructed in 1852 and served as the first store on the north coast of the county. It was located half a mile west at the whaling station. It was moved to this location in 1878 and became the Sebastian Store, the only commercial enterprise remaining from that period. The structure became a California Historical Landmark in 1960. Pictured below from left to right at the dedication ceremony are Mary Edith Sebastian Hansen, J.C. "Pete" Sebastian, Manuel "Mel" Sebastian Jr., his wife Lenore Wilkinson Sebastian, and Tony and Marguerite Sebastian. (Both, courtesy of HCSLOC.)

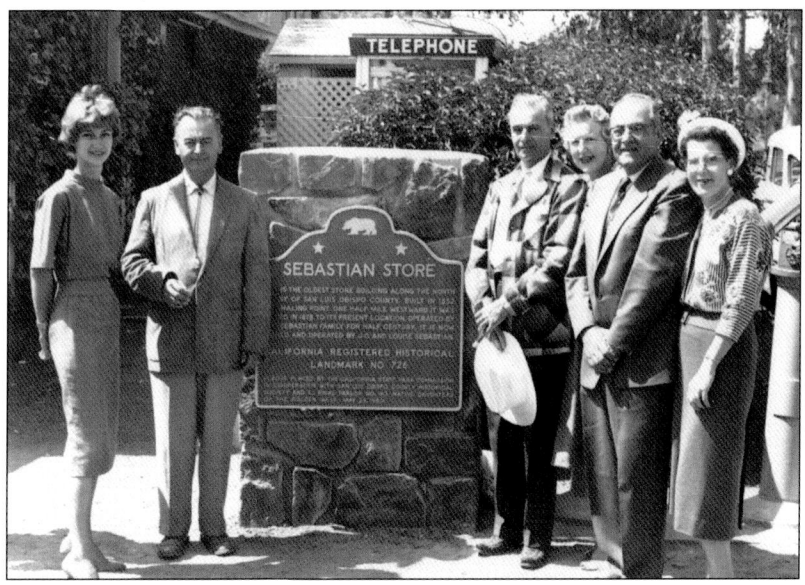

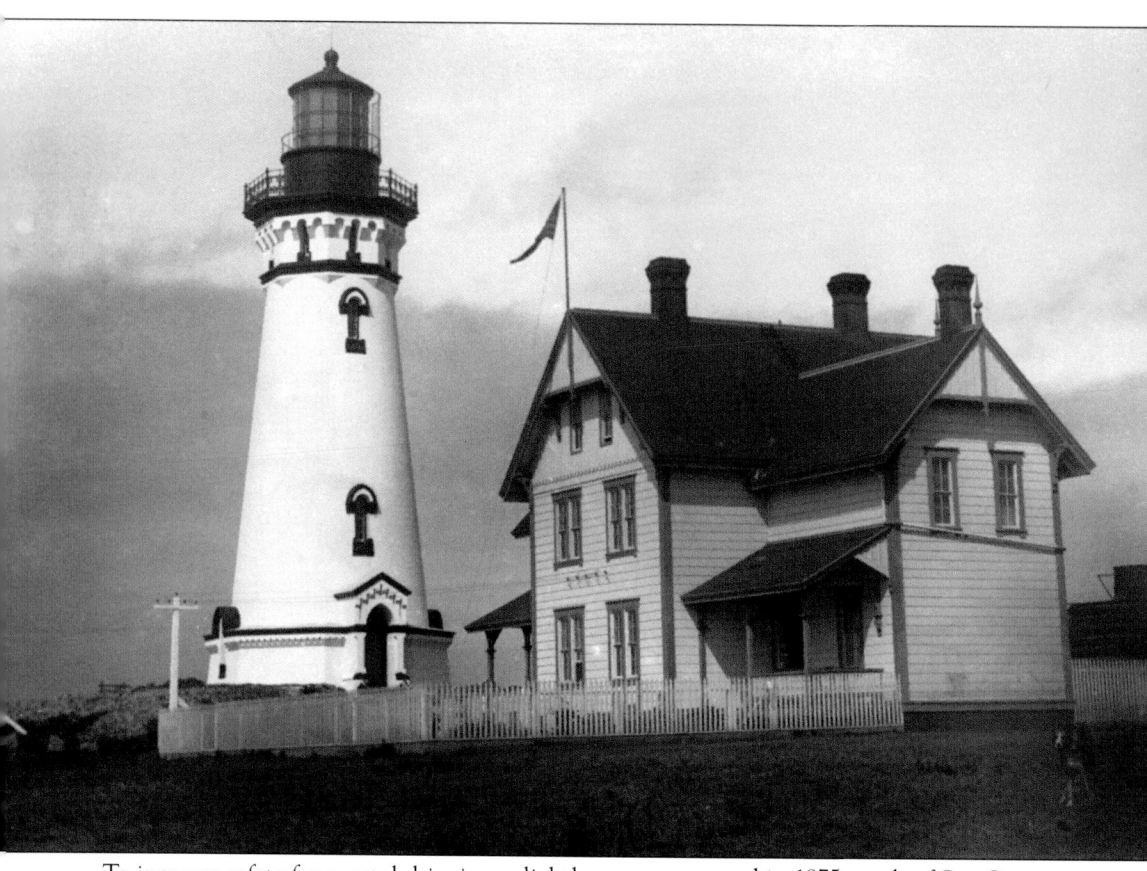

To increase safety for coastal shipping, a lighthouse was erected in 1875 north of San Simeon at Point Piedras Blancas to warn ships of the rocky shoreline. The light from an oil vapor lamp was visible up to 20 miles at sea. Its first-order Fresnel lens was made in Paris. Later replaced, the lens is displayed now on Main Street in Cambria. Earthquakes damaged the structure leading to the decision to remove the top three floors, which amounted to about 30 feet of its original 100-foot height. The two-story dwelling to accommodate two lighthouse keepers and their families was finished in 1876 and housed three families. Rainwater was collected seasonally in tanks, and when that was not sufficient, it was hauled in. Eventually, a well was sunk, and a pump powered by a windmill was added. The site is operated as a historical park and wildlife sanctuary. (Photograph by Alice Phelan Nock, courtesy of RN and PNM.)

Dairying was the fourth of the industries that propelled growth between 1866 and 1890. Spanish cattle had been brought to the area during the mission era, and they produced beef, hides, tallow, and horns. But a drought in 1862–1864 decimated them. The Steele brothers, successful dairymen in San Mateo County, moved their operation to San Luis Obispo County, which they called "cow heaven." Others followed, building herds suitable for butter and cheese production at Green Valley, San Simeon, and Santa Rosa Creek. The climate was moderate, and winter rains produced abundant feed. For a time, the county was California's largest producer of cheese. Jeffrey Phelan's dairy farm is depicted above in an artist's rendition around 1883 and in a photograph below taken a decade or so later. The viewpoint of the latter is rotated 90 degrees. (Above, courtesy of Myron Angel; below, photograph by Alice Phelan Nock, courtesy of RN and PNM.)

By 1869, cheese production was underway in several area creameries. Swiss Italian dairy farmers began arriving in the area in the mid-1870s. The unification of Italy and high tariffs on dairy products there produced economic problems that spurred thousands of farmers to emigrate. The success of the early immigrants encouraged others to follow. Among them was Joseph Fiscalini, who arrived in 1876. By 1884, Fiscalini had acquired land and a herd of cows and was joined by his wife, Margherita. They are pictured here three years later. At the time, there were about 50 dairy ranches in the area and collectively 3,500 cows. The names of other such immigrants who dairy farmed in the Cambria-Cayucos area include Barlogio, Bassetti, Bassi, Biaggini, Brugheli, Filipponi, Maggioria, Muscio, Righetti, Tognazzi, and Tomasini. (Left, courtesy of Gloria Fiscalini; below, courtesy of Aarica Wells.)

The creamery at Harmony was known successively as the Excelsior ("fitted with all the best appliances used in the cheese factories of New York"), later the Diamond (opposite page), and then as the Harmony Valley Creamery Association in 1913. It was a cooperative with about 200 members. Producing butter and cheese for distant markets was challenging, due to improving sanitation requirements. Many creameries failed. Marius G. Salmina is credited for leading the cooperative during the changes in the industry. Danish American Carl Hansen was hired as butter maker and plant superintendent—a wise choice, as he had previously been awarded a gold medal for butter making. The photograph of the Harmony Valley Creamery Association annual meeting in 1936 shows only a third of the attendees. In Cambria, the California Creamery & Butter Company operated for five years out of the large tin building on Main Street that now houses the Garden Shed. During the peak season, about two tons of butter were produced there every day. It was cut and wrapped for sale before shipment to San Francisco. (Courtesy of HCSLOC.)

Another industry developed in the area, but it did not produce as much of an economic impact. An abundance of abalone, kelp, and sea lettuce along the coast drew Chinese into the export business. They harvested and dried the abalone and seaweed for shipment to China via San Francisco. Sea lettuce (ulva) was actually farmed. Suitable rocks along the shore were prepared by scorching them with smoldering pine shavings in a wire basket. This reduced competition from other seaweeds and improved the rooting of ulva, which was ultimately harvested. How Wong, perhaps last of these sea farmers, was still drying seaweed in the 1970s. His house above the cliffs is shown above. For a time, a Japanese fisherman named I. Yamamoto had an abalone-drying operation at the mouth of Leffingwell Creek (below). (Above, courtesy of Debbie Soto; below, courtesy of HCSLOC.)

The commercial center for these varied industries was a settlement on Santa Rosa Creek that had gone by several names. The earliest given by Europeans was San Benvenuto, when the Portola expedition camped near the creek in 1769 and 1770. The Spanish name indicated a place suitable for a large mission. But that name did not take root and survives only in friar Juan Crespi's journal. An unflattering moniker for the new community was "Slabtown." It was likely coined by a San Luis Obispo resident. The two towns were vigorous rivals in the county, and the derisive reference was to the use of untrimmed slabs of lumber for walls. Some locals called themselves "Roseans," others referred to the community as San Simeon. This early view from Cambria Hill includes Cambria Hall (the dark building center left), which was the largest assembly hall in the county. Between the two trees on the right are buildings supported on posts above the creek. They face Bridge Street, which forded the creek, as the downhill slope of the street indicates. (Courtesy of HCSLOC.)

The US Postal Service forced a decision regarding the town's name when it required three names to be submitted for a permanent post office. The community responded with Santa Rosa, Rosaville, and San Simeon. The first already existed elsewhere in the state, the second was too similar to Roseville, which also existed, and the last would cause confusion. Peter A. Forrester, pictured here in Masonic regalia, was prominent in business and public affairs and made the first local survey of downtown. He suggested Cambria, the name of a county in Pennsylvania where he had lived. In 1870, that name was adopted for the post office serving the 500 people living within two miles. *Cambria* is the Latin name for Wales, which has led to other explanations for the name. Forrester's house was on Center Street next to the Greenspace Creekside Reserve. (Both, courtesy of CHS.)

Early routes leading to Cambria are not easy to detect now. They followed Indian trails that avoided wetlands and deep water. From the south, a trail passed through Green Valley and then overland to a crossing of Santa Rosa Creek near the site of current Coast Union High School. It avoided the large *laguna* to the west that is depicted on Estrada's *diseño*. From there, it followed the north side of the creek to the intersection of today's Main and Bridge Streets (above). From San Simeon, a trail came south to San Simeon Creek from which it went overland past the community cemetery and down Bridge Street to Main Street. The lower photograph shows the view toward town from that road, with Santa Rosa church on the hillside. (Right, courtesy of CHS; below, photograph by Alice Phelan Nock, courtesy of RN and PNM.)

This view of Cambria is from 1872 or 1873. Santa Rosa church is left of center on the hill. Below it, the large white building is the Cambria Hotel, built by George W. Lingo. Across from it was the Lull and Grant Store. Lee Street (Burton Drive) did not exist yet. Center Street crosses diagonally from lower left to right. The large dark building on the far left was Cambria Hall, the largest assembly building in the county. Scott Rock is just visible behind the largest tree on the right. This local landmark was named for Greenup Scott, who had a home below it on Santa Rosa Creek Road. (Courtesy of HCSLOC.)

The approach from the south came through what is now the Cambria Nursery and Florist, down the east side of the ravine, through Tin Village, and then forded the creek to connect with Bridge Street. Bridge Street is named for the small bridges across open ditches that connected buildings on both sides to the street. In 1932, the ditches were replaced with a large culvert and paved over. To make the approach down Cambria Hill easier and the crossing less hazardous, it was rerouted to the opposite side of the ravine (where it is now), and the Lee Street (Burton Drive) bridge was built in 1888. That bridge was a worthy setting for the photograph above. The view below, from years later, shows the ascent of the road up Cambria Hill. (Above, photograph by Alice Phelan Nock, courtesy of RN and PNM; below, courtesy of CHS.)

Up Bridge Street, the community's second church was built in 1874, also by local carpenter Henry Williams and Merritt Trace. It housed the first Presbyterian congregation in San Luis Obispo County. The bell tower was added in 1906. Former president Calvin Coolidge and his wife, Grace, attended a service in 1930. The church choir (below) is pictured here about 1950. The poinsettias out front suggest Christmastime. When a new and larger Presbyterian church was built elsewhere in town, a newly formed Baptist congregation bought the building and remained until its own new facilities opened in 1988. Cambria Vineyard Church similarly used the building as a temporary home. The historical manse next to the church was built in 1891 and is now the Bridge Street Inn. (Both, courtesy of CHS.)

The photograph above shows upper Bridge Street (also called Church Street) with the Presbyterian church belfry (center right) and bridges over the weed-filled ditch on the left. Currently, a dentist office is in the house on the far left. Carpenter Henry Williams built three houses here on this street, including one below for himself and wife, Sallie, in 1877. It was later owned by Capt. Lorin Thorndyke, the first lighthouse keeper at Piedras Blancas, and his wife, Margaret. Three restaurants—Robin's, the Little House on Bridge Street, and the Tea Cozy—have been more recent occupants. Santa Rosa church is on the hill behind. (Both, courtesy of CHS.)

These men were photographed in front of the Proctor House Hotel on a voting day in the 1880s. Women were not yet allowed to vote. The men's surnames were Armstrong, Evans, Franklin, McClelland, Morss, Apsey, Johnson, Terril, Scott, Bray, Ridgon, Russell, Doty, Warren, Feltz, Woods, Vaughn, Conway, Campbell, Thomas, Compher, Proctor, Dodson, Sherman, and Kirkpatrick.

48

Many were related; for example, five of the men were named Morss. Swiss Italian and Portuguese Azorean names are absent from this list because the right to vote required citizenship, either conferred at birth or through naturalization. The latter would have required some proficiency in English, which many immigrants lacked. (Courtesy of Dawn Dunlap and Forrest Warren.)

49

With about 1,000 residents, Cambria was the second largest town in the county. Its timber-built business district is shown (above) in 1888. In 1889, it took only a few hours for it to be devastated. The fire started in the alley behind the three-story Proctor House Hotel (upper right, where Bob & Jan's Bottle Shop is presently). The hotel's water-storage tank proved useless due to a leaky hose. The fire leapt across the intersection, consuming other commercial buildings and some homes. Despite the devastation, the post office operated the next day (below) with the postmaster using a counter salvaged from the fire. People rebuilt quickly. In fact, William Leffingwell Sr. is quoted as saying "the fire actually seemed to lend new life to the town, even though life savings and fortunes were swept away." (Above, courtesy of Dawn Dunlap; below, courtesy of CHS.)

Three
SETTLING IN

Following the pioneer era of development and establishment of local industries, the next stage was about settling in, establishing the services and institutions the community would need to prosper. The I.O.O.F. (Independent Order of Odd Fellows) Building was erected after the Great Fire of 1889. The Swiss-American Supply Co. was downstairs with the lodge hall above. M.G. Filipponi, in the white shirt, owned the business. Pine trees were a traditional decoration for festive events. (Courtesy of HCSLOC.)

In 1877, the Hope Fire Department was organized with 28 volunteers and a man-hauled bucket-and-ladder wagon that was housed in a building in today's Heritage Oaks Bank parking lot. This photograph from about 1883 shows the fire department band ready to lead volunteer firefighters in a Fourth of July parade, some of who would be hauling the wagon draped with flags. Santa Rosa church is in the background. (Courtesy of CHS.)

To fight fires, volunteers formed bucket brigades and used leather buckets to draw water from townspeople's cisterns, wells, water troughs, and Santa Rosa Creek. This 1901 fire wagon was put together by a local blacksmith, John Eubanks. In 1933, a Lincoln Town Car was rebuilt with a tank and became the first motorized fire equipment. The Cambria Fire Protection District was formed in 1935. (Photograph by Ralph Morgan, courtesy of HCSLOC.)

One response to the calamitous 1889 fire was J.D. Campbell Jr.'s (right) development of a private water system for the town. As part of it, he constructed a rock-lined tank on the hillside above Wall Street. Along with fighting future fires, the threat of flooding argued for a community water system. Inundation of wells and cesspools would create a health hazard. A comprehensive water system would not come until half a century later and a sewage system a couple of decades after that. In the lower photograph, Austin Waltz (left) and Wilfred Lyon are shown in 1949 working to extinguish a blaze at a small house owned by William Gaily. They credited a recently purchased Mack truck for speedily pumping a large supply of water from the sizable tank. (Right, courtesy of Alberta Dodson Stewart Collection, HCSLOC; below, courtesy of HCSLOC.)

One-room schools were numerous in the area, serving scattered rural families. On San Simeon Creek, there were the Home and New Era Schools. The Olmsted School was in Green Valley. Students and their teacher, Helen Stewart, are pictured above about 1895. On Santa Rosa Creek there were the Mammoth Rock and Santa Rosa Schools. Farther afield were the Washington and Pacific Schools to the north and the Harmony School to the south. The Santa Rosa School (below) was built in 1881, and the bell tower and porch were added in 1890. After one-room schools in the area were consolidated in the 20th century, the building was relocated to town and served other purposes. (Above, courtesy of Alberta Dodson Stewart Collection, HCSLOC; below, courtesy of HCSLOC.)

In 1868, the Hesperian School District was formed from parts of the San Simeon and Santa Rosa School Districts to serve the town's children. The first Hesperian School was located on the hill above the intersection of Main and Lee Streets. It had a large room with a front porch supported by four carved redwood columns. The porch became an entrance hall when a second room was added. It was moved to the west, and the larger New Hesperian School (above) was built in its place in 1906. Hesperus was the Greek god of the West and is associated with the evening star. The word *Hesperian* occurs elsewhere in Cambria to name a lane and a fraternal lodge. The New Hesperian School was used until consolidation of one-room schools in the area required a larger building, the Cambria Grammar School (below). It was built in 1936 by F.C. Stolte Company, the contractor in charge of construction at William Randolph Hearst's La Cuesta Encantada. (Above, photograph by Alice Phelan Nock, courtesy of RN and PNM; below, courtesy of HCSLOC.)

Cambria's first high school was private, begun by Prof. Merritt R. Trace in 1890. Students from remote farms would board with families in town. Initially, the high school was housed in the Benjamin H. Franklin Building at the corner of Lee and Main Streets. This undated photograph is of a junior class. Pictured here from left to right are (first row) Earl Van Gordon, Professor Trace, and Reuben Phillips; (second row) Tom Phillips, Lena Leffingwell, Annie Muma, Ella Lynn, and George Lull. Lull later became a district attorney of San Francisco, and Professor Trace later transferred to San Miguel and then San Jose, where a school was later named for him. Below, the 1906 championship basketball team players are, from left to right, Violet Armstrong, Hazel Van Gorden, Edna Bland, Mabel Bright, Phoebe Maggetti, and Janie Turri. (Above, courtesy of HCSLOC; below, photograph by Alice Phelan Nock, courtesy of RN and PNM.)

Coast Union High School was established in 1921, and facilities were built in 1925 east of town on Santa Rosa Creek. The location is across from where the Portola expedition had camped in 1769–1770. In 1925, Cambria's high school building (above) and one in Santa Maria were named the most beautiful in the state. The photograph below shows the school and shop buildings, tennis courts, and athletic field in the late 1930s. On April 29, 1939, the high school was closed in honor of William Randolph Hearst's birthday. In 1968, high school commencement ceremonies were held at Hearst Castle because a new auditorium and gym were under construction. (Above, courtesy of CHS; below, courtesy of WLC.)

After the Great Fire of 1889, buildings at the intersection of Main and Bridge Streets were erected, reconstructed, and changed hands. The store at the northeast corner (where the Tin Building is now) had Anderson, Lyons, and Franklin as various proprietors. The bicycles seen in the photograph above include a penny-farthing (large and small wheels). Signs on the left advertise the Western Union Telegraph Office and San Luis Stage. Next door, R.A. Minor and George Dickie's hardware store (below) sold De Laval cream separators for dairies and gasoline for the new automobile trade. George Dickie had earlier set up a freight line between Cambria and the wharf at San Simeon. (Above, courtesy of Gary Smith; below, courtesy of WLC.)

William M. Lyons moved from Morro Bay and established his first general merchandise store at the corner of Main and Bridge Streets in 1906. Two years later, it was located about half a block west on the main floor of the Ridgon Building. The windows display clothing and S&W canned goods. Signs in the photograph indicate that upstairs housed the Native Sons of the Golden West meeting room and a doctor's office. In fact, nearly all the local fraternal organizations met there. Gas jets inside the store and above the doors were fueled from a carbide plant behind the building. (Electricity came to Cambria in 1921.) A decade later, Lyons' Store became the Red & White Store, part of a chain of independent grocery stores in small towns. Roland Houtz remembers the Red & White in his youth: a pickle barrel behind the cash register and a steep stairway leading to a narrow balcony loaded with clothes, shoes, and intriguing goods. In the back room, his first job was candling eggs to determine if they were fertile. (Courtesy of WLC.)

For years, Albert S. Gay was the local justice of the peace. Hearings and small trials were held in his house on Bridge Street (above), where the Cambria Garden and Arts complex is now. Larger trials were held in the lodge room above Lyons' store. A constable was the other aspect of local law and order. Cambria's first jail was at the end of Bridge Street and only large enough for overnight lockups. For various reasons, it was rebuilt and relocated several times. The constable Elbert "Boots" Blake is pictured here equipped with a blackjack. When he was a boy, he had red boots that he wore all the time, hence the nickname. One of Cambria's jails, dated 1888, is at the Pinedorado grounds. (Above, courtesy of WLC; left, courtesy of CHS.)

Cambria's original library was also located in the Gay home (opposite page). Beginning in 1921, Annie Gay was custodian and had it open 23 hours a week. The library offered more than books. Wilfred Lyons recalled listening to an Atwater Kent Radio there, using a headset. It was one of the first radios in Cambria. Later, the library relocated to a building on Main Street, and in 1938, it moved to the back room of the Bank of America, accessed by the door on the far right (above). In 1964, the library moved to the water district building at the foot of Bridge Street, which has since been razed. Cambria's first purpose-built library (below), designed by Maul-Stewart Associates, opened in 1981. In 2014, library services moved to a new building twice the size of the former location. (Above, courtesy of CHS; below, photograph by Justine Shaffner.)

The Bank of Cambria and post office appear in a 1910 photograph (above) that includes, from left to right, businessman George Dickie, bank manager James Stewart, two unidentified trustees, and Alberta Dodson Stewart, who assisted her husband in the bank. James Stewart is also shown (below) inside the bank. The sign advertises traveler's checks, and the counter is decorated with lilies. A new Bank of Cambria building (previous page) opened in 1928 and closed permanently on February 16, 1933, for a federally mandated bank holiday and did not reopen. That same year, the Bank of America acquired the building and opened for business. It remained there until moving into new quarters a block west in 1979. The former bank building is now home to the Vault Gallery. (Both, courtesy of Alberta Dodson Stewart Collection, HCSLOC.)

Fraternal lodges, benevolent societies, and other organizations played an important part in the life of the community. They offered opportunities for socializing, monitoring the wellbeing of fellow residents, and charitable activities. Cambria's first fraternal order was the Masons, organized in 1869, whose San Simeon Lodge No. 196 was one of the earliest in the county. The Hesperian Lodge No. 181 of the Independent Order of Odd Fellows formed in 1870. The Morse Rebekah Degree Lodge No. 25, a branch of the Independent Order of Odd Fellows for women, formed in 1877; the Cambria Grange (Patrons of Husbandry) in 1873; and Cambria's American Legion of Honor in 1881. The Cambria Parlor No. 152 of Native Sons of the Golden West was organized in 1875 and the El Pinal Parlor No. 163 of Native Daughters of the Golden West in 1908. The Good Will Society of Cambria, presumably for young women and perhaps of local or regional origin, is pictured here performing part of its fan drill in about 1895. (Courtesy of Mabel Bright and HCSLOC.)

These two views show continuity and change. Above, on the left, is the two-story brick Rigdon Building. To its right are the San Francisco Bakery and Soto's Market. The center building is Rigdon Hall (built by Fred Ott and sold to Elmer S. Rigdon), which hosted dances and theatricals. On the far right is the B.H. Franklin Building, which housed the first high school. In a later view (below), the brick Rigdon Building is in the center, occupied by the Red & White Store. To the left of it are an unidentified store, then Camozzi's Hotel, and Reali's bar and café on the corner. To the right of the Rigdon Building are Soto's Market, with its distinctive facade, and Cambria Hardware. Right of it, Rigdon Hall (later Dickie's) has had its upper floor removed, and B.H. Franklin is replaced by Dickie's Cambria Service Station. (Above, photograph by Alice Phelan Nock, courtesy of RN and PNM; below, courtesy of CHS.)

Soto's Market is a modern landmark with a history reaching back about 100 years. Joaquin "Jack" and Agnes Maggetti Soto purchased an existing meat market on Bridge Street in 1917. He added groceries for sale and his name on the front. In 1919, the enterprise moved to a building on Main Street. The distinctive stucco facade dates from 1939. Soto's added 100 frozen food lockers in 1945. Three generations of Soto family members ran the business for 72 years. Pictured above are Harold Lanini, Wilfred Lyons, and Jack Soto. A fire in 1951 destroyed the Rigdon Building (below) and dislodged the fraternal orders that met upstairs. Their records, furniture, and regalia were lost. Because neighboring buildings did not have party walls, men who fought the 11-hour blaze were able keep adjacent walls wet and stop the fire from spreading. (Both, courtesy of CHS.)

Having spent his entire life here, Wilfred Lyons was one of Cambria's important historians. He was born in 1912 in the manse next to the Presbyterian church on Bridge Street. He attended local schools and worked in his father's store and later at Soto's Market next door. He married Hazel Kennett and they lived in a small house on Center Street for 29 years and then moved to his parents' house (above) on Bridge Street, across from the house where he was born. Wilfred and Hazel are shown at a Hawaiian-themed party thrown by the Women's Athletic Club of Cambria Pines, another of the social and service organizations in the community. (Both, courtesy of CHS.)

At the corner of Bridge and Center Streets, McCain's Saloon subsequently was a blacksmith shop, newspaper office (*Cambria Critic*), bank, restaurant and bar, artist's studio, and woodworking shop. After World War II, it was a restaurant and bar known as Rip and Riley's, famed for good times, dances, and fights. The moniker "Bucket of Blood" was attached and stuck. It has been renovated and now houses Evans & Gerst Antiques. (Courtesy of CHS.)

At one time, there were five saloons in a two-block stretch of Main Street. At Mariano's Saloon, Tony Mariano, the proprietor, is shown behind the bar in 1904. Built on the same site during Prohibition in 1922, Camozzi's was a hotel, card parlor, pool hall, and barbershop. It was only in 1933 that selling alcohol was again legal. The establishment lives on as Mozzi's Saloon. (Courtesy of CHS.)

George and Lucinda Morris Proctor bought and improved the property at the northwest corner of Burton Drive and Center Street. They built and then sold the two-story house and adjacent lots to John Jr. and James Taylor, who had the large redwood structure built. It was rented to Jacob Carroll to operate a blacksmith shop. The building still carries his name. (Courtesy of CHS.)

This house replaced a Victorian house built by the same carpenters who constructed the Squibb House nearby. It was built in 1935 for native Cambrians Frank and Mabel Wittenberg Souza. The Grey Fox Restaurant preceded Robin's Restaurant, which now operates from the house. Robin and Shanny Covey began business serving food from the back room of a health food store on Main Street that now houses the Indigo Moon restaurant. (Courtesy of CHS.)

Rufus and India Scott Rigdon purchased this house in 1898, following renovations by Merritt Trace. In 1905, they installed a bathtub, the first in Cambria. Their son Elmer Scott Ridgon was involved in lumber, ranching, mining, and brick making. His brickyard (below) was located where Santa Rosa Catholic Church now stands. Subsequently, Rigdon was elected state assemblyman and then state senator. Later, the building was a dinner hall and an inn. The palm tree (above) is noteworthy. Reportedly, a traveling man with horticultural wares appeared in town with palms, cypress, redwood, and other specimens to sell. Consequently, palms became a feature of Lee Street, though only this one remains. In the 1920s, William Randolph Hearst paid $1,000 for each palm dug up, and had them transplanted to his La Cuesta Encantada. (Above, courtesy of WLC; below, photograph by Alice Phelan Nock, courtesy of RN and PNM.)

This view of Cambria from the east was taken by Alice Phelan Nock around the turn of the 20th century. Santa Rosa Creek comes into it from the lower left and Santa Rosa Creek Road from the lower right. The white building on the hill (center) is Santa Rosa church. To its right, grave markers are evident. To its left is the original Hesperian School with an addition on the rear.

The rangeland on the horizon was the Russell ranch (now Fiscalini Ranch Preserve). The group of farm buildings at its base was the Ridgon ranch. The Rigdon Building and Rigdon Hall are identifiable as well. (Photograph by Alice Phelan Nock, courtesy of RN and PNM.)

This 1920s view is from the intersection of Main and Lee (Burton Drive) Streets. On the far right is the rear of a car at Dickie's Cambria Service Station. The wall of Rigdon Hall next door advertises Shell products. Beyond Rigdon Hall, the dark building is Soto's Market, then the two-story brick Rigdon Building, Camozzi's, and on the corner, the Cambria Hotel. Beyond, the prominent two-story brick building is the I.O.O.F. Building, and the square-fronted building in the distance is Zoppi's Market. The house to its left might have been J.D. Campbell Jr.'s home. His livery stable is the barn on the left in the photograph. It is barely visible between the post-1921 power poles. In 1916, mercury prices rose with the outbreak of World War I, and Cambrians felt prosperous enough to plan for their own electricity-generating plant. This did not materialize, so it was only in 1921 that a public utility line reached town. (Courtesy of WA.)

In addition to the industries that gave Cambria its start, there was another—Hearst family enterprises—that became a constant. George Hearst employed local men on his ranches beginning in 1865. William Randolph Hearst's construction of La Cuesta Encantada (above) provided employment for local people for decades, as did staffing and maintaining the complex. His expectation that it would one day be a museum and open to the public proved correct. Tourism associated with it has created more jobs. In accounts of their dealings with the Hearsts over many decades, Cambrians typically have been positive and appreciative. Pictured here are William Randolph Hearst Sr. (second from right) and his sons, from left to right, William Randolph Hearst Jr., David Hearst, and Randolph Hearst. (Above, courtesy of HCSLOC; below, courtesy of CHS.)

Although dairying continued in the Cambria area into the 1960s, dairy farmers began converting their operations to beef cattle as early as the 1920s. Increasingly stringent governmental regulation of the dairy industry was a major reason. In 1930, Harmony Valley Creamery Association became a depot affiliated with the larger Challenge Cream and Butter Association. The view is of the Phelan Ranch at the turn of the 20th century. (Courtesy of APN.)

Three Cambria area cattlemen have been honored as Cattleman of the Year by their peers in San Luis Obispo County. Edwin Walter (shown here) was elected in 1981. He and his wife, Barbara Helen, had ranches near Cambria, Harmony, and the Carrizo Plain. Vernon Soto, honored in 1999, came from a family dating back 10 generations in California. He married a Cambria girl, Althea Smithers. (Courtesy of Dawn Dunlap.)

Louis Fiscalini was chosen Cattleman of the Year in 1996. He was a descendent of the early Swiss Italian immigrants Joseph and Margherita Fiscalini. His wife, Betty Jean Bowser, was a devoted nurse to her patients. Louis's aunt, Lucy M. Fiscalini (right) owned the ranchland adjacent to Cambria that was known as the Fiscalini Town Ranch. She donated portions of it and sold others, leaving over 400 acres that would ultimately be conserved. Her generous donations of land provided sites for Santa Rosa Catholic Church and the Veterans' Memorial Building. The view is of part of the ranch close to Cambria. (Right, courtesy of Catherine Sala and Mary Ann Van Paul; below, courtesy of CHS.)

The Fiscalini Town Ranch was originally part of Rancho Santa Rosa. In the 1860s, the ranch was subdivided and logged, and it was sold in the 1870s. Dawn Dunlap reports that barley and oats were grown on the eastern part of the ranch over the next two decades to provide feed for the livery stables in town. Then it became a dairy farm, with a residence, barn, creamery, and silo. Subsequent owners Ernest and Helen Galbraith established the Alpine Guernsey Dairy, and unlike others, they delivered whole raw milk and cream to customers daily. (Other local dairies sold to the Harmony Valley Creamery Association.) The Galbraiths also grew alfalfa, Sudan grass, and sugar beets. They built a cold storage room and a new residence on the north side of the creek. (The former is now the Bicycle Kitchen and the latter, home to the Black Cat Restaurant.) In the 1940s, the Galbraiths leased the land for growing strawberries and pansies. After Lucy Fiscalini bought the ranch, it was used to grow potatoes and as grazing land for beef cattle. (Courtesy of BS.)

Four
CELEBRATING THE TOWN

Scattered homesteads and an isolated location meant people looked close to home for entertainment. Community celebrations brought people together and made a welcome change from daily routines. As Cambria's festivities gained county-wide attention, more people came and were drawn from farther away. Camping sites were rented to out-of-town visitors. (Courtesy of CHS.)

A group men and boys called the Growlers is pictured here with ragged costumes and masks on July 4, 1893. They were affiliated with the fraternal group the Native Sons of the Golden West. One man holds up a hat on a pole, and several hold crude walking sticks. The parade route was decorated with pine trees secured to the wooden sidewalks. Behind the revelers, the brick I.O.O.F. Building is on the far left. The Lull and Guthrie general merchandise store was on the main level, with the lodge meeting room above. To its right, the tall building is the Cambria Hotel, which had a bar on the lower floor. People with flags peer from the upper hotel windows. The center building has two barber poles projecting from the right window. (Courtesy of Mrs. Jeffrey Phelan and HCSLOC.)

In the early days, there was a picnic ground on the hill north of what is now Heritage Oaks Bank. In the 1870s, the grounds were moved to Phelan's Canyon and finally to a clearing in the forest known as Phelan Grove on today's Covell ranch. Logging had cleared enough land for horse races, rodeo events, and baseball games featuring the Cambria Kelp Eaters and Templeton Cherry Pit Spitters. Trees provided shade for picnics, concerts, games, and speeches. Horse-drawn wagons are shown above waiting for the parade to turn from Main Street into Bridge Street and then up to Phelan Grove. Below, wagons are lined up in a procession that added ceremony to these occasions. Notice the bridges across the ditch that gave the street its name. The two-story barn-like building on the right was Jeremiah Johnson's livery stable. (Above, courtesy of WLC; below, courtesy of CHS.)

The annual celebration of Swiss Independence Day featured horse-drawn wagons, an honorary king and queen, and a profusion of Swiss and American flags. Above, men and boys in costume stand on the wagon that is turning onto Bridge Street. The W.M. Lyons grocery and merchandise store and Minor & Dickie hardware stores follow the tradition of using pine trees as decorations for celebrations. Left, with the pines as a backdrop, the royalty for this Swiss Independence Day celebration are Eugenio Bianchini and his daughter Palmyra. Helvetia (on her crown) is the ancient name of Switzerland. Bianchini, a Swiss immigrant, was a dairyman, owner of the Klau Mine, and a distributor of illegal Canadian whisky. Along with Swiss heritage and the Fourth of July, Cambrians have celebrated Labor Day, California Admission Day, May Day, and more recently, Pinedorado. (Both, courtesy of CHS.)

Ranch owner Jeffrey Phelan (above, far left) is shown with Eugenio Bianchini (in the white apron) overseeing the barbecue pit at Phelan Grove. Bianchini and another local, Joaquin Cantua, were considered masters of barbecue. Whole cows and hogs were roasted and served free, having been donated by farmers and ranchers for these community events. According to Geneva Hamilton, sometimes a traveling Spanish band from Jolon or Adelaida would come by horseback over the mountains to entertain, guitars hanging from the saddle horns. Hamilton also notes that the Hearst family took an active interest in Phelan Grove celebrations, encouraging Wild West show activities and parade participation, donating beef, and providing trophies for winners of competitions. As many as 2,000 people attended these picnics. The lower photograph shows a picnic in the forest with well-dressed women, men, and children. (Above, courtesy of CHS; below, photograph by Alice Phelan Nock, courtesy of RN and PNM.)

Above, the Native Daughters of the Golden West are shown at Phelan Grove. The women are dressed in traditional white, and some have elaborate hats. The horse arena and baseball diamond were in the open space visible through the trees. On the horizon are Pine Mountain (left), the much taller Rocky Butte (center), and Vulture Rock (right). Below, attending this Cambria camping party in 1884 were, from left to right, Mrs. Fischer, Alpha Carey, Harry Logan, Mayme Logan, May Laird, Elta Carey, Fred Marsh, Maggie Arbuckle Van Gorden (daughter of William Arbuckle who bought land from the Van Gordens), and John Rigdon (younger brother of Elmer S. Rigdon). The photograph might have been taken by Max Fischer, a local druggist and photographer. Chaperoned camping parties were popular, a way for young people to socialize. (Above, photograph by Alice Phelan Nock, courtesy of RN and PNM; below, HCSLOC.)

Bull riding, shown here, was a popular rodeo competition at Phelan Grove. According to Robert Soto, wild stock would be driven down from the Hearst ranch to be used in the rodeo. Other events showcased horsemanship skills. Before the days of horse trailers and good roads, strings of horses would be tied head to tail and led overland from Paso Robles by cowboys. According to Dawn Dunlap's lecture notes, "The importance of horses and horsemanship during California's pastoral days of Spanish and Mexican rule cannot be emphasized enough. An easterner visiting Monterey in the early 1840s wrote, 'Californians do not partake of much fish in their meals, undoubtedly because they cannot fish on horseback.'" (Above, courtesy of CHS; right, courtesy of Robert Soto.)

Schedule of Events

EIGHTH ANNUAL CAMBRIA RODEO

COWBOY DANCES Saturday and Sunday Nights

PHELAN'S GROVE
Cambria, California

Sunday, June 30, 1935

ENTRIES MUST BE IN 10 P. M. SATURDAY
NO ENTRY ACCEPTED ON SUNDAY

ADMISSION TO RODEO
Adults, $1.10 Children, 55c (Including Tax)

The Cambria Rodeo Association was formed in 1928 to organize these weekend-long events. Dances were held Saturday and Sunday nights at Rigdon Hall, with rodeo competition on Sunday, including "bucking broncos, bull riding, bulldogging steers, team roping, and wild cow milking." According to an account in the *Cambrian*, as many as 6,000 people attended. The Cambria rodeo moved in the 1930s from Phelan Grove to new rodeo grounds south of Santa Rosa Creek. It had a quarter-mile race track, holding pens, saddling and bull stalls and chutes, a hillside grandstand, and bleachers accommodating 3,000. More horse events were added in 1938, including "best Hackamore horse, best reined horse, buggy races and horseback races for ladies and for children under 14." The next three rodeos were advertised more broadly and with important sponsors: chambers of commerce in San Luis Obispo and Cambria, the American Quicksilver Company, Acme Beer, and Standard Oil of California. (Courtesy of CHS.)

Another annual celebration on a smaller scale was Chinese New Year or Spring Festival. A pig was roasted in an oven like the one shown above, having been basted to create a lacquer-like coating. During the several decades that Chinese worked in the Cambria area, they had a site in town where they celebrated, gambled, socialized, and conducted business. The Chinese Center was off Center Street on land owned by Johanna Gans. Among the simple buildings were laundries, bunkhouses, an opium den, and a temple built in the 1880s. The temple had fraternal as well as religious uses, and might more accurately be called an association hall. It alone remains from that era. It was restored by Greenspace–The Cambria Land Trust and is part of its Creekside Reserve. The exterior wall boards were made of local pine. (Above, photograph by Alice Phelan Nock, courtesy of RN and PNM; below, courtesy of WA.)

Cambria also celebrates itself by conserving and popularizing its own history. Paul Squibb and his wife, Louise Groves Squibb, founded the Midland School, a college preparatory boarding school in Los Olivos, California. They oversaw its administration and taught a variety of classes there for 23 years. After retiring to Cambria, they bought the former Darke House in 1954. The Squibbs developed a keen interest Cambria's history, and in the 1950s, he served as president of the San Luis Obispo Historical Society. His personal files were an early acquisition of the Cambria Historical Society, which was formed in 1990 by Ken Cooper and Wilfred Lyons. In 1980, Squibb commented that Cambria "has become a boom town with all the attendant inconveniences, but this has happened almost everywhere in California" (the *Cambrian*, January 12, 1980). For years, the Squibbs made a practice of picking up trash while out walking. The term coined for this was "squibbing." In recognition of this contribution to the community, the county's board of supervisors proclaimed May 1 Squibbing Day. (Courtesy of HCSLOC.)

Built in the 1860s, the Guthrie-Bianchini House was owned by several of the community's early leaders, including Benjamin H. Franklin. In 1882, Samuel and Sarah Woods Guthrie bought it and made improvements. Guthrie had worked as an accountant at the Oceanic Mine and at the Lull and Grant Store before becoming a full partner in the store. After he died, Sarah Guthrie sold the house to Eugenio and Louisa Bezzini Bianchini in 1914. After their deaths in the 1940s, their sons, William, Walter, and James, lived there. The Bianchini heirs, assigns, and creditors took decades to sort out ownership issues, during which time the building deteriorated. Shown above, from left to right are Samuel and Sarah Woods Guthrie, Margaret Woods Ott, and Mary Woods Leffingwell. Below is the Guthries' beautiful parlor. (Both, courtesy of CHS.)

Acquisition and restoration of the building was a challenging project undertaken by the Cambria Historical Society with support from the community. The rear section was built in 1870 with locally milled pine. The front section was built of redwood in 1882. The pine had deteriorated so much (above) that the original section had to be removed and rebuilt. A new foundation for the entire building was constructed as well. The house was placed in the National Register of Historic Places in 1979 and purchased by the Cambria Historical Society in 2001. The restoration project was completed in 2008. It is now the Cambria Historical Museum, with permanent and changing exhibits and an heirloom garden. (Both, courtesy of CHS.)

In 2014, the Cambria Historical Society purchased the Maggetti House next door to the museum. The town's physician, Dr. Russell Parkhurst, and his wife, Mary, had lived in the one-story house and sold it to Louis and Lala Galbraith Maggetti in 1894. He had a leather goods and shoe repair shop on Main Street. Maggetti is shown above in front of his establishment in a car with his son Johnny. For his family with two boys and four girls, he added the second story for the girls (below). The Cambria History Museum, Maggetti House, Bucket of Blood, and Greenspace Creekside Reserve with its Chinese temple are the core of the Cambria historic district, which is recognized by San Luis Obispo County. (Both, courtesy of CHS.)

The creation of a chamber of commerce is a celebration of a town's businesses, a vote of confidence by merchants in a community's future. The Cambria Chamber of Commerce was organized in 1932 and headquartered in the Flats, the new commercial area west of Cambria. Carl Daniels designed and built the structure pictured above. Robert Jones, one of the developers of Cambria Pines, was the first president and ultimately donated the building to the chamber. From 1932 to 1949, the building served as a town hall, meeting room, and party venue. During World War II, the US Coast Guard took over the building for a kitchen and command center. Cambria's farmers' market (below) is a weekly celebration of the community that originated in 1988. (Above, courtesy of CHS; below, courtesy of WA.)

Five

CAMBRIA PINES

As momentous as the discovery of cinnabar, the buzzing of the first sawmill, the naming of the town, and the Great Fire of 1889, so was the incorporation of the Cambria Pines Development Company in 1927. Harry E. Jones was a Hollywood developer who, with his two brothers, saw a new kind of potential in Cambria's forest. The Joneses marketed lots as a resort development called Cambria Pines. (Courtesy of CHS.)

John and James Taylor had logged much of their ranchland directly west and south of Cambria, and their heirs sold the land to the Joneses' Cambria Pines Development Company. This was subdivided and eventually became known as Lodge Hill (bottom of the map), Park Hill (top left), and Happy Hill (top). Some of the streets were named after Harry Jones's wife, Leona, and five children: Ardath, Lucille, Marjorie, Richard, and Ernest. Between Park Hill and Happy Hill, a new business district or new town was also developed in what locals called the Flats. A later development called Pine Knolls Estates is to the right of Park Hill. This map from 1963 also shows a proposed highway bypass of Cambria. (Courtesy of Jim Murren.)

Whether for a vacation or a vacation home, the forest-by-the-sea experience with balsam-scented ocean breezes was promoted as healthful. With gradually improved roads, this retreat was within reach of California's growing urban centers. It was heralded as the "San Joaquin Valley's Ocean Front," and the "Only Spot on Southern California Coast Where Giant Pine Trees Meet the Sea." The caption for the photograph is "Pines and Ocean Meet." Lots, many as narrow as 25 feet, cost as little as $100. The long-term consequence of such small lots was the loss of the trees that were a big part of the place's attraction. It would take nearly 50 years for the county to increase the buildable lot frontage to 50 feet. (Both, courtesy of CHS.)

$100 OCEAN LOTS $100

A SMALL DOWN PAYMENT AND

17c A DAY--GET ONE

ONLY SPOT ON SOUTHERN CALIFORNIA COAST WHERE GIANT PINE TREES MEET THE SEA

Graveled streets and water to every lot. Electricity and telephone available. All improvements included in price of lot.
This is a lifetime opportunity. Property is located on the new Roosevelt Highway. This will be stopping place for thousands. A city will grow here, and every lot will increase tremendously in value. This is a wonderful place to live, both winter and summer. Superb climate. Magnificent scenery. Great pine trees virtually to water's edge. Swimming, horseback riding, hunting, fishing, tennis, Great place for children. Best buy on Coast today. Investigate this important opportunity at once.

SEND TODAY FOR FULL INFORMATION AND ROAD MAP

CAMBRIA PINES "BY-THE-SEA"

SAN JOAQUIN VALLEY'S OCEAN FRONT

NAME ..
Write name plainly for further information with no obligation

ADDRESS ..
Drop in nearest P. O. Box

CITY ...
No postage required

CABIN ACCOMMODATIONS—OH BOY! WHAT MEALS—FREE CAMPING GROUNDS
HUNTER'S PARADISE—FISHERMAN'S DELIGHT.

I am interested in ☐ Trout Fishing, ☐ Deer Hunting, ☐ Duck Shooting, ☐ Swimming, ☐ Boating, ☐ Horseback Riding, ☐ Week-end Retreat, ☐ Summer Home, ☐ Permanent Residence, ☐ Investment, ☐ Making Money

Cambria Pines and its forest setting were a sportsman's paradise with ocean fishing and seasonal trout fishing. For hunters there were deer, quail, dove, duck, and brant. A postcard (above) shows two deer strung up outside the Cambria Pines Lodge. Below, three men wearing ties, with one in a jacket and vest, exhibit abalone that the man with rolled-up pant legs possibly harvested. The bar he holds was to pry abalone off the rocks. For beachcombers, moonstones and other semi-precious rocks could be gathered. According to promotional materials distributed by the Cambria Pines Development Company, such recreational and sporting activities, enchanting views, and moderate climate, the area could "not be duplicated in Southern California." (Both, courtesy of CHS.)

By the 1930s, there were two distinct towns: Cambria, the 19th century community on the bank of Santa Rosa Creek and Cambria Pines to the west and south. Cambria had the bank, bars, stores, and churches. Cambria Pines was the home of the new chamber of commerce. It also had 12,000 building sites and a small commercial center. At one time or another, each community hosted a newspaper, grocery store, and hotel. Plots along the road through Cambria Pines were earmarked for commercial development. Its single artery was a westward extension of Cambria's main street and the state highway named the Roosevelt Highway. The Benson Hotel, managed by Hattie Benson, housed a grocery and restaurant on the first level (left). The chamber of commerce is the gabled building at the center of the photograph. Great care was taken to distinguish Cambria Pines "on the Roosevelt Highway" from the original settlement of Cambria. The distinction was reinforced by the contrasting pronunciations: Cambria (as in Camelot) and Cambria Pines (as in "came and went"). (Courtesy of CHS.)

In addition to extolling the virtues and availability of lots in the forest and lots with ocean views, the Cambria Pines Development Company highlighted long-term investment potential. The company asserted in advertisements that the 1930s economic depression and the lowest building costs in years created a perfect climate for investing in property and construction; real estate was certain to appreciate in value. The company initially worked from Los Angeles and then added offices in Fresno, Long Beach, and San Francisco. Free transportation was offered for excursions to view property. For one sales promotion, Henry Jones hired a blimp to drop leaflets along the route from Los Angeles. These were invitations to a promotional barbecue at Cambria Pines. Model homes, most often of log construction, were available for viewing. Stuart Hamblen, a popular singing cowboy, pitched Cambria Pines on radio commercials out of Long Beach. During the 1930s, advertisements increasingly promoted the development of full-time residences. (Courtesy of CHS.)

As ownership of automobiles increased, servicing them became a new business. Initially, gasoline was available from pumps in front of a hardware store. George Dickie had the first true gasoline station in town where the French Corner Bakery parking lot is. His Cambria Service Station also sold fishing tackle. In a 1919 interview, Dickie said he was "waiting for the tourists." The Bianchini House is visible behind the station. (Courtesy of WLC.)

The Old Stone Station was the first gasoline station in Cambria Pines. The distinctive rock was quarried off Santa Rosa Creek Road. The restaurant in the remodeled building keeps the historical name. A garage for servicing vehicles was built next door by Curtis "Woody" Woodland, and among the vehicles he serviced were those of the Hearst family. (Courtesy of CHS.)

The Cambria Pines Lodge was an important element in marketing Cambria Pines lots. It attracted people with its forest setting and activities and served as a sales office. At first, these activities were housed in a huge circus tent, then in a log building with a lounge and dining room (above). Accommodations were close by in log cabins (below). The lodge sported a tennis court, croquet ground, children's playground, and riding stable and offered guided hunting and fishing expeditions. The riding stable had Morgan, Arabian, and Thoroughbred horses for hire. Polo matches were played on the airfield to the south. Themed Saturday-night campfires were a particular attraction for Cambria residents as well as guests. Both amateur and professional entertainers performed, and there were always sing-alongs. Hundreds of people joined in these fun-filled evenings around the fire. (Both, courtesy of CHS.)

THE CAMBRIAN

The *Cambrian* newspaper began publishing in 1931, which coincided with the Cambria Pines Development Company's efforts to promote and market lots and develop a vacation resort. For years, the company took more space in the newspaper than any other advertiser. Events at the lodge, like the Saturday-night campfires and the accompanying entertainment, were front page stories. Construction of homes and businesses was also newsworthy, frequently with photographs of newly completed homes and businesses. The *Cambrian* published lists of recent guests at the lodge and also those staying at the Benson Hotel, Blue Bird Auto Court, and Music's Whispering Pines Court. Poems by Cambria Pines residents and visitors were included, which extolled the beauty, comfort, and pleasures of the area. In 1933, the *Cambrian* began printing its title in a log-inspired typeface. Later, it added the motto, "Where the Murmur of the Pines and the Music of the Sea are Accompaniment for our Symphony of Contentment." (Courtesy of the *Cambrian*.)

Marketing lots in Cambria Pines was aided by an airstrip across the road from the lodge. Cambria Pines Airport initially accommodated private planes. In the aerial view, the two intersecting runways are visible to the lower right. The lodge is in a forest clearing to the right of center in the photograph. Navigation instructions for the airport warned that "trees surround field except on east." In 1933, scheduled direct flights to Cambria began with Pacific Seaboard Air Lines flying daily from Mills Field in San Francisco and then on to Los Angeles Grand Airport in Glendale. Flight times were about two hours. Similarly, flights were offered from Glendale to Cambria Pines and on to San Francisco. The aircraft was a five-passenger Bellanca. The airfield was subsequently subdivided and marketed as Cambria Pines View. (Above, courtesy of WA; below, courtesy of Eddie Coates.)

The era of tourism transformed of some of Cambria's historical houses into public accommodations. The Lull House (right of center), built in 1880 by Cambria merchant George W. Lull, was sold in 1899 and turned into a rooming house. Following its sale in 1930, individual units were built and advertised as a cabin court. This reflected the need to accommodate automobiles. After 1945, new owners added more cabins and named it the Bluebird Motel. The concept of a motel originated 20 years earlier at the Motel Inn in San Luis Obispo. In 1936, Cambria and Cambria Pines boasted four hotels, four auto courts, five restaurants, and a campground. But often this was not enough space for visitors, for over Memorial Day weekend that year all available rooms were occupied, and extra bedrooms in private houses were rented out. Locals had a saying that reflected the boom and bust aspect of tourism in the area: "Chicken from Memorial Day to Labor Day and feathers the rest of the year." (Courtesy of Ken Cooper.)

The need for more accommodations would increase dramatically, people said, once the Roosevelt Highway connecting San Simeon to Carmel opened. The idea of a coastal road was proposed as early as 1897 by Dr. John L.D. Roberts of Seaside, California. He gained support from state senator Elmer S. Ridgon, a Cambria native, who led the effort to obtain state funding for the project. While originally deemed important for commerce and tourism, during World War I this was reconsidered, and the highway was called necessary for defense. Bixby Bridge (above) was one of the project's key engineering feats: the longest single-arch span in the world. In 1934, state highway engineer Lester Gibson drove the first car the length of the road, which was still under construction (below). It took three more years to finish the highway. (Both, courtesy of CHS.)

Highway dedication activities in 1937 kicked off with a banquet at Cambria Pines Lodge. Harry E. Jones was toastmaster. Guests included the governor's wife, Jessie Lipsey Merriam (the governor had another engagement in Los Angeles), and Alice Rigdon, the widow of state senator Elmer S. Rigdon. Ray W. Shamel, president of the Cambria Chamber of Commerce was a speaker, as was Bertha Gyorgy, mayor of Cambria. The next day, a caravan of cars drove north for dedication ceremonies first at San Simeon, then north of Lucia, where a drinking fountain memorialized the late Senator Ridgon (above). The dedication ceremonies concluded when Gov. Frank Merriam (who had arrived from Los Angeles) helped clear a boulder from the road at Pfeiffer Redwoods State Park (below). (Both, courtesy of CHS.)

World War II interrupted further development of tourism. Housing was always scarce in Cambria, but the influx of servicemen exacerbated the problem. A local rent control committee kept an eye on rental rates. The Coast Guard took possession of the Benson Hotel, nearby lots, and adjacent buildings. The Army leased the Cambria Pines Lodge. Rationing, plane watching, and scrap collecting became routines of community life. Pictured above are Coast Guard troops mustering in front of the Benson Hotel on the Roosevelt Highway. Their job was to protect American shores against sabotage, enemy submarines, enemy landings, and "fifth column activities along the coast." In 1951, the Cambria Air Force Radar Station (below) was built and activated south of town to maintain long-range radar communications and electronics. It closed in 1980. (Above, courtesy of CHX; below, courtesy of HCSLOC.)

On a December night in 1941, the Union Oil Company's oil tanker *Montebello* (above) left Avila heading north to Vancouver with a cargo of oil and gasoline. It was shadowed by a Japanese submarine, which at 5:30 a.m. fired two torpedoes when they were offshore near Cambria. One struck the ship and within about an hour it sank. The crew made it to shore with the assistance of quick-thinking Cambrians. The wreck remains on the ocean floor, its cargo having dispersed. In June 1944, five young women newly graduated from Coast Union High School set off for wartime work at the Lockheed aerospace plant in Burbank. Pictured here from left to right are Ethel (Camozzi) Head, B.J. (Lownes) Rossi, Roberta (Goodall) Galbraith, Betty (Soto) Williams, and Althea (Smithers) Soto. (Above, courtesy of CHS; right, courtesy of Roberta Goodall Galbraith.)

105

William Randolph Hearst (pictured here in 1923) first applied the term museum to his home above San Simeon Bay in a letter to his architect, Julia Morgan, in 1927. The only time Hearst opened the hilltop to the public was in 1932 as a benefit for the building fund of another of Morgan's local creations, the Monday Club of San Luis Obispo. In 1958, the Hearst Corporation donated the main house, guest houses, gardens, and all of the art objects within, as well as 120 adjacent acres, to the California State Division of Beaches and Parks. The opening of the coast road south from Carmel to San Simeon in June 1937 and the opening of Hearst Castle two decades later in June 1958 ushered in two tourism booms for Cambria. The coast road, designated as Highway 1 in 1964, was initially unpaved and often closed by frequent rock and mud slides. Although now paved and its adjacent hillsides stabilized, Highway 1 still challenges drivers and their passengers' nerves with precipitous drops and rewards them with unparalleled scenery. (Courtesy of Bancroft.)

In response to greatly increased tourist traffic to Hearst Castle and up the coast, a bypass of the old route through Cambria was built in 1962–1963. Local merchants objected to it, fearing it would reduce the commerce on which the town depended. Others were shocked by the devastation of the forest and landscape (above). The former highway in town needed a new name. Robert Waltz suggested El Camino de Los Perros, because every store and establishment had a pet dog. Instead, it became Main Street. This single, conventional name for the route through town symbolized the linking of the two communities. Integration had begun with construction of the elementary school between them in 1936 and a single water service in 1934. The postcard below shows the view from one business district toward the other. (Above, courtesy of California Department of Transportation; below, courtesy of HCSLOC.)

Due to its location in a narrow valley near the ocean, Cambria has been subject to repeated flooding. In 1914, after weeks of heavy rain, water gushed down the ditches along upper Bridge Street and turned streets to mud (above). Wells and cisterns overflowed. Wilfred Lyons reported that a mile west at the Flats (now called the West Village), there was a lake "almost year round for several years, and locals would hunt ducks on it." Memories of the flood of March 1995 are still fresh. Water levels began rising steadily in the West Village, and business owners barricaded their shops, to no avail, as seen below. In the East Village, Burton Drive Bridge was blocked by large rocks. Four roads into Cambria were impassable, and the Windsor Boulevard Bridge was closed, stranding 1,000 people on Park Hill. (Above, courtesy of WLC; below, photograph by David Middlecamp, courtesy of the *Tribune*.)

Six

CELEBRATING THE FOREST

Attitudes about the local forest have changed over the years. It was necessary to Native Americans, useful to settlers, a background for the community's routines and celebrations, and a marketable commodity. More recently it has been celebrated in name. The reputation of Cambria pines was strong enough to warrant a brand for lettuce as well as other products. In the past 25 years, it has been celebrated through conservation. (Courtesy of CHS.)

CAMBRIA PINES LETTUCE

Grown, Packed and Shipped by
WILLIAMS & BLASS
SAN LUIS OBISPO, CALIFORNIA

109

In 1948, a Lions Club was formed, and it took the big step of borrowing money to purchase, move, and refurbish a building from Camp San Luis for use as a youth and community recreation hall. Lucy M. Fiscalini donated the land. Corrine Koontz loaned $7,500 to the Lions. Moving the structure required dividing it into several sections, a slow journey up Highway 1, and then reassembling them. To pay off the debt and support the club's programs, the Lions decided to hold an annual fundraising event in conjunction with Labor Day in 1949. The three-day festival featured food booths, games, barbecues, dances, a fishing contest in Santa Rosa Creek, and entertainment. Over the years, kiddy cars, a toy train, an art show, live performances, and classic cars have been added. A parade has become a highlight of the weekend with floats, horses, marching bands, and calliope. The photograph shows one of the early celebrations. (Courtesy of CHS.)

A contest was held to name the Labor Day weekend event. Bea Becker of Hollywood submitted the name "Pine-dorado" and won. The "pine" part was obvious. "Dorado" suggests gilding, hence "festival of the gilded pine." El Dorado was a storied locale said to be in the Americas that abounded with gold and precious stones. Cambria's equivalent gold and gems were "its scenic beauty; more specifically its pine-covered hills, and its ideal situation against a setting of blue ocean," according to the *Cambrian*. As it turned out, that first Pinedorado was postponed until November because the roof was not yet on the refurbished community building. Horses and riders (right) are part of Pinedorado parades. Both mature and young women have vied for the honor of Pinedorado Queen. Contestants in 1957 were, from left to right, Jeanne Friend, Sharon Yost, and Judy Thorndyke. (Right, courtesy of the *Tribune*; below, courtesy of HCSLOC.)

Pinedorado in 1966 was heralded as the "biggest on the Central Coast, and one of the best-known activities of a Lion's club in the Western states," with thousands of visitors expected. It coincided with the town's 100th anniversary. The organizers brought in Big Sur resident Linus Pauling as a judge for the parade. He had won Nobel prizes for chemistry (1954) and peace (1962). The sweepstakes winner was a float titled "Saturday Night 1866," pictured above, sponsored by Cambria Pines Realty. It sported two vignettes: one of a man proposing marriage and one of a man in a washtub being shampooed by his wife. Seen below is a Mayflower-themed float from the 2011 parade. (Above, courtesy of the *Tribune*; below, courtesy of Tom Cochrun.)

A few years before Pinedorado began, a camp was developed in the forest on the south edge of Cambria. It was part of a large ranch on the coast with a panoramic view of the Pacific Ocean. Camp Ocean Pines was a nonprofit camp and conference center that became affiliated with the YMCA organization. A midden at the camp is testimony to an earlier Native American settlement there. (Courtesy of COP.)

Harper and Georgiana Farr Sibley of Rochester, New York, owned the ranch and allowed a 13-acre portion to be used as the summer camp. The photograph shows boys boarding a school bus to Camp Ocean Pines. An earlier camp called Pine Crest had opened on Cambria's Happy Hill in 1941. (Courtesy of HCSLOC.)

In 1998, a new nonprofit organization took charge of Camp Ocean Pines, with the mission of fostering appreciation of the natural world through creative activities. A broad array of art, performance, and music camps have been held in recent years, with a particular concern for acknowledging the natural setting of the Monterey pine forest and coast. Well over 100,000 children have participated, as have adults attending conferences and retreats. (Both, courtesy of COP.)

Through the years, volunteers have helped build and maintain Camp Ocean Pine's facilities, which, by 1960, included cabins and the main lodge. Among the improvements made were 10 cabins built with straw bales, as well as timber and siding milled from wind-felled trees from the property. The beam in the photograph was one of these pines. The story of the connection between Cambria's forest and nations in the Southern Hemisphere will follow shortly, but a related anecdote about Camp Ocean Pines is pertinent here. The bunk beds for the cabins were crafted by a volunteer using plywood from Chile. Those plywood sheets were made from *Pinus radiata* trees, which are grown there. However, the seeds that started Chile's lumber industry in the 1940s originally came from Monterey pine trees, like those at Camp Ocean Pines. (Courtesy of COP.)

In the two decades after the establishment of Pinedorado and Camp Ocean Pines, Americans were becoming aware of the need to aggressively protect forests, wildlife, open space, and water resources. In California, reactions to the 1969 Santa Barbara oil spill and the creation of the California Coastal Commission in 1972 signaled the new understanding. People became aware of the environment and its potential degradation from human actions. By the 1980s, plans developed by San Luis Obispo County for the Cambria area included "assuring the protection of coastal resources such as wetlands, coastal streams, forests, marine habitats, and wildlife, including threatened and endangered species." As with most cultural changes, the period was contentious. Beginning in 1991, Arthur Van Rhyn's cartoons in the *Cambrian* and elsewhere provided a humorous commentary on local controversies, including the environmental ones. (Above, courtesy of LCSLOC; left, courtesy of Arthur Van Rhyn.)

In 1986, the Land Conservancy of San Luis Obispo County was formed to "permanently protect and enhance lands having important scenic, agricultural, habitat and cultural values for the benefit of people and wildlife." Among its first projects was a partnership with the California State Coastal Conservancy to purchase forested lots in Cambria's Fern Canyon. The coastal conservancy funds local nonprofit entities to carry out projects in accord with its mission: to purchase, protect, restore, and enhance coastal resources and provide access to the shore. Cambrian Henry Kluck was instrumental in conserving Fern Canyon. He served on the board of the Land Conservancy of San Luis Obispo County and lamented the inevitable loss of forest when Cambria's 25-foot-wide lots were built upon. Pictured here is the canyon's Henry Kluck Trail through the pine-oak forest. The Land Conservancy also holds a conservation easement on a 175-acre forest tract on the north edge of Cambria. (Photograph by Judy Hildinger, courtesy of LCSLOC.)

Greenspace–The Cambria Land Trust, was founded in 1988. Its initial goal was to gain easements from landowners along Santa Rosa Creek so that a hiking-biking trail could be created. But quickly it became clear that such a trail could not be developed without broader information about the ecology of the creek. With a growing sense of mission, the young land trust set its sights on a comprehensive plan for the lower reach of Santa Rosa Creek. The plan would identify management goals to protect and restore the natural resources of this part of the creek. To produce such a plan, funds were needed to hire environmental professionals. To begin raising money, an art auction was held, as artists and art lovers were among the early vocal supporters of local conservation. For more than a quarter century, that partnership has lasted. Pictured here is an art festival at the Greenspace Creekside Reserve. (Courtesy of Bill Knight.)

With funds from the California Coastal Conservancy, Greenspace was able the conserve a sizable forest tract known historically as Strawberry Valley and now called Strawberry Canyon. In the past, locals gathered the California wild strawberries that grew there (above). Financial contributions from neighbors and others have made possible acquisition of several contiguous properties. Adjacent to Greenspace's Strawberry Canyon Preserve are 600 acres of forest, riparian area, wetland, and coastal terrace owned by others. Together, this forms a significant wildlife habitat. Conserving smaller segments of the forest began in 1993. Greenspace's pocket parks are small wooded or open spaces scattered throughout the community. Some are accessible, while others are left natural as wildlife habitat. Credit for conserving the Cambria forest can be attributed as well as to the California Department of State Parks, which in 1931 began acquiring shoreline and forest north of Cambria (below). (Above, courtesy of BS; below, courtesy of WA.)

Among the most dramatic and popular conservation successes has been the 417-acre former Fiscalini Town Ranch. The ranch had been owned by Lucy M. Fiscalini, but it had to be sold to pay inheritance taxes. Betty and Louis Fiscalini (left) tried to convince the California Coastal Conservancy to fund the purchase of the ranch. With hundreds of acres of oceanfront open space and 70 acres of forest, it would be a unique community amenity (below). But, they were unsuccessful. The ranch was purchased by a development company with plans for hundreds of homes. It went bankrupt and was purchased by another developer. Efforts to buy the property for community benefit culminated in its purchase in 2000 using about $10 million of state funds and $1 million raised locally. A donation of land by Mid-State Bank sealed the transaction. (Left, courtesy of Gloria Fiscalini; below, courtesy of California Coastal Records Project.)

The highly popular open space and forest trails are owned by the Cambria Community Services District with Friends of the Fiscalini Ranch Preserve as conservation easement holder. Friends of the Ranchland, the North Coast Small Wilderness Area Preservation, and the American Land Conservancy were among the organizations pushing the project forward. Dedication ceremonies in 2000 included hundreds of supporters holding a ribbon stretched the length of the ranch. Celebrants pictured above from left to right are Bob Bose, Darlene Bowe, Barbara Snyder, Jennifer Rogers, Carmen K. Perez, and Katie Lindsay. On the 10th anniversary of the achievement, people stretched hand-to-hand along the bluff trail (below). (Both photographs by Bert Etling, courtesy of the *Cambrian*.)

A frightening environmental challenge arose in 1994. Not only could Cambria's forest be lost through development, it could be lost through a human-introduced disease. The potentially devastating threat came in the form of pitch canker. Probably transferred to California from the Southeast, it was first noticed in Santa Cruz County in 1986. Insects carrying pitch canker spores on their bodies take advantage of damaged or stressed trees and invade them. Stopping the spread of pitch canker seemed virtually impossible since spores move easily wherever humans travel—particularly along highways. Early on, scientists projected up to 85 percent mortality. The forest could be decimated. Possibly for the first time, people had to imagine Cambria without its signature pines due to disease as well as further development. The photograph from the Fiscalini Ranch Preserve shows former rangeland, Monterey pine forest, and Rocky Butte on the horizon. (Courtesy of BS.)

There is an intriguing international aspect to the pitch canker threat. As early as 1788, seeds from pinecones had been taken from Monterey to France, and seeds were sent to Britain, Australia, and New Zealand for study in the 1830s. A pine plantation was established near Auckland, New Zealand, in 1866 with the seed source recorded as Santa Rosa. In those faraway places, the scientific name *Pinus radiata* was used. By the 20th century, the pine was being grown in the Southern Hemisphere for lumber and pulp; the photograph shows a plantation in Australia. (In New Zealand, native trees had become protected by law.) About 10 million acres of *Pinus radiata* are now in cultivation in the Southern Hemisphere. Thus, when pitch canker threatened to decimate California's native stands of the pine, there was alarm far beyond. The three California stands in Cambria, Monterey, and north of Santa Cruz are the only ones in the world with genetic diversity. (Courtesy of State Library of South Australia.)

In 1998, a group of forestry professionals from New Zealand toured Cambria's forest and learned firsthand about pitch canker disease. They expressed concern that the pathogen might find its way to New Zealand. One of them, an entomologist, hoped that it would not get established in New Zealand, for "such a spread would be an absolute disaster" for its lumber industry. They were so concerned that after their visit they washed their clothing and threw away their shoes before returning home. The same year, New Zealand officials instituted an embargo on all imported pine seeds as part of the effort to keep the fungus out. In the photograph above by Kathe Tanner, Richard Hawley of Greenspace shows the New Zealand contingent the telltale features of a diseased tree: branch dieback from a lesion, and resin produced to stop the infection from spreading. One visitor said she was "appalled that they let you build in amongst the trees and cut the trees down. In New Zealand, you cannot cut down a native tree." (Above, courtesy of the *Cambrian*; below, courtesy of WA.)

When Hearst Castle and the adjacent acreage were transferred to the state of California, the remainder of Hearst Ranch continued as a working ranch. However, over the years, the Hearst Corporation announced plans for development along the coast. One plan proposed eight distinct villages with a total population of 65,000. A subsequent plan was for a destination resort with six hotels and three golf courses near San Simeon village. Local opposition grew strident, and by 1997, the scheme was a national news story about the loss of what was called the last undeveloped portion of Southern California's coast. Negotiations with the Nature Conservancy and then the American Land Conservancy produced a conservation plan. Nearly the entire ranch would remain in agriculture, and a large stand of Monterey pine forest near the coast would be safe as well. About 15 miles of ocean frontage west of Highway 1 would be deeded to the California Department of State Parks and Recreation. Historical San Simeon village could have limited development for tourism. For this project, the state used $100 million of funds authorized by voters to conserve California's landscapes. (In the photograph, part of La Cuesta Encantada is visible upper right.) (Courtesy of Dennis Curry.)

People are raising Monterey pines in both the Southern and Northern Hemispheres but for very different reasons. In the former, the pines are raised for lumber and paper pulp. Around Cambria, seedlings are raised to sustain the threatened species and the vulnerable forest. Since Europeans first remarked about the pines two centuries ago, more than a quarter of that forest has disappeared. On the positive side, nearly 1,500 acres of pine and oak forest around Cambria (68 percent of the stand) are already protected through public ownership, conservation easements, or similar means. The Nature Conservancy's conservation of about 800 acres of forest on the Covell Ranch and purchase of the 100-acre Williams Ranch by the California Department of Fish and Wildlife helped immensely in reaching this level of protection. The map shows the stand with the forest's undeveloped sections in light tone and the sections with development in dark tone. (Courtesy of Jones & Stokes, Cambria Forest Committee.)

Along with existing protections, forest lovers also see hope in the creation and approval of the Cambria Forest Management Plan. In the wake of logging, development, and fire suppression measures, the forest's viability depends on proactive management and conservation. Among the plan's goals are maintaining a mix of forest ages, enhancing habitat for native plants and animals in the forest, and controlling fire hazards. The plan has been approved but remains unfunded. It stems from discussions by a group of Cambrians who regard the forest as part of an ecosystem rather than as individual lots. A recent challenge to the forest takes the form of regional drought. Because they are shallow-rooted, Monterey pines cannot reach deep for the moisture they need, and beneficial fogs are not year-round occurrences. Over centuries, the forest has experienced expansion and contraction, which suggests an inherent resiliency; however, that was when it only faced the challenges nature brings. Now, humans distress the forest as well. (Courtesy of BS.)

Discover Thousands of Local History Books Featuring Millions of Vintage Images

Arcadia Publishing, the leading local history publisher in the United States, is committed to making history accessible and meaningful through publishing books that celebrate and preserve the heritage of America's people and places.

Find more books like this at
www.arcadiapublishing.com

Search for your hometown history, your old stomping grounds, and even your favorite sports team.

Consistent with our mission to preserve history on a local level, this book was printed in South Carolina on American-made paper and manufactured entirely in the United States. Products carrying the accredited Forest Stewardship Council (FSC) label are printed on 100 percent FSC-certified paper.

MADE IN THE USA